THE FIRST CELEBRITY SERIAL KILLER
IN SOUTHWEST OHIO

CONFESSIONS OF THE STRANGLER ALFRED KNAPP

RICHARD O JONES

Published by The History Press
Charleston, SC 29403
www.historypress.net

Copyright © 2015 by Richard O Jones
All rights reserved

First published 2015

Manufactured in the United States

ISBN 978.1.46711.750.0

Library of Congress Control Number: 2015933020

Notice: The information in this book is true and complete to the best of our knowledge. It is offered without guarantee on the part of the author or The History Press. The author and The History Press disclaim all liability in connection with the use of this book.

All rights reserved. No part of this book may be reproduced or transmitted in any form whatsoever without prior written permission from the publisher except in the case of brief quotations embodied in critical articles and reviews.

To my parents

CONTENTS

Foreword, by Rick Kennedy	7
Acknowledgements	9
The Cincinnati, Hamilton and Indianapolis Line	11
Confession Upon Confession	35
The Strangler's Tales	55
A Puzzle to His Attorneys	87
No Match for Old Sparky	117
Notes	133
Bibliography	135
Index	141
About the Author	144

FOREWORD

The expression "truth is stranger than fiction" applies to countless criminals along the dark places of our history and especially to the life of an Indiana thug named Alfred Knapp, a ruthless strangler of young girls whose behavior was insanely compulsive, manipulative, vain, flamboyant and downright idiotic.

You've likely never heard of Alfred Knapp, but in 1903, the handsome and habitual criminal became an overnight media sensation after he confessed to murdering five young women and girls in Ohio and Indiana (including his third wife) over the course of a decade. The newspapers called him "America's Jack the Ripper." His electrocution in 1904 in Columbus, Ohio, prompted newspaper headlines across the nation, and thousands of curiosity seekers swarmed the funeral home to view his corpse.

With the passage of time, he has joined a roll call of violent psychopaths now long forgotten—his legacy tucked away in old newspaper microfilm reels and musty court records that are rarely visited. True crime historian Richard O Jones has revived Knapp's bizarre and disturbing story. A veteran newspaper reporter, Jones not only weaves together a compelling and highly readable narrative but also explores the social fabric of southern Ohio at the dawn of the twentieth century and its industrial cities of Hamilton and Cincinnati.

Knapp's notoriety was propelled by a newspaper industry at its economic zenith. Before radio and television, American cities supported multiple newspapers with sizable staffs competing with screaming headlines and special editions. Media sensationalism is not a new phenomenon. It was

rampant in the Victorian age, and Knapp exploited it. After his arrest, the only action capable of keeping his mouth shut was the application of 1,750 volts of electricity while he was strapped to a chair.

Hundreds of detailed articles from Ohio and Indiana newspapers provided Jones with extraordinary source material for re-creating this detailed and lively account. Jones's research is meticulous, but the book doesn't read like a simple rehash of newspaper articles. Jones is a longtime resident of the Hamilton area, and he brings color to the narrative from knowing firsthand the neighborhoods where key events in Knapp's life occurred.

My family is personally connected to one of Knapp's evil deeds, which Jones covers in detail. In 1902, Knapp brutally strangled and stabbed my grandmother, Stella Motzer Kennedy, when she was a young girl in Hamilton, Ohio. Miraculously, she escaped his clutches, and with blood streaming down her face, she raced down a dark alley to safety. Her trail of blood guided her family back to a spot in the alley where her younger sister laid unconscious after being struck by Knapp. Then my traumatized six-year-old grandmother accused the wrong man. The jury acquitted the innocent man, leading to a public relations disaster for the Motzer family. The case remained unsolved until Knapp, from his prison cell, confessed to the assault of the Motzer girls.

My grandmother essentially took the nightmare to her grave. She never told her own children about it. Still, the attack affected her for the remainder of her life, and the event ultimately scarred her entire family. Just months after Knapp's execution, her own mother (my great-grandmother) died suddenly at age thirty-five. I am led to believe Knapp's vicious assault on her little girls and its aftermath contributed to her death.

There is never one victim of a violent crime. It impacts entire families in ways that can last for decades. Perhaps this is the greatest value in preserving crime history—to allow descendants of the victims to better appreciate the anguish carried by their ancestors.

Make no mistake about it. Jones has written an entertaining piece of history that reads like a detective yarn. Given the family wreckage created by Knapp more than a century ago, this book is sure to find its way to readers who may learn about a dark period in their own family histories that would have been lost forever.

—RICK KENNEDY

Rick Kennedy is the author of Jelly Roll, Bix & Hoagy: Gennett Records and the Rise of America's Musical Grassroots. *He co-authored with Randy McNutt* Little Labels Big Sound. *He lives in Cincinnati, Ohio.*

ACKNOWLEDGEMENTS

Thanks most of all to Barbara Didrichsen—my sweetheart, best friend and trusted first editor. Without your support and encouragement, this book would not have happened.

Thanks also to the staff at the Public Library of Cincinnati and Hamilton County, the Lane Libraries and the Indianapolis Public Library; to Valerie Elliot and Samantha Harris at the Smith Library of Regional History; to Kathy Creighton at the Butler County Historical Society and Ed Creighton for his vast knowledge of Cincinnati history; and to my cadre of "first readers" for the valuable advice on the earliest drafts.

Also thanks to Jim Blount, Curtis Ellison, the Colligan History Project, the Miami University Hamilton Downtown center and anyone else who helped give voice to True Crime Historian.

Thank you also to Sandra M. Orlett, photographer.

THE CINCINNATI, HAMILTON AND INDIANAPOLIS LINE

The *Hamilton Evening Sun* put out its first early edition five hours ahead of normal press time on Wednesday, February 25, 1903, ready for travelers at the local train stations by 10:00 a.m. The blazing headline read "KNAPP ARRESTED FOR WIFE MURDER," and below it, "STARTLING AFFAIR BROUGHT TO LIGHT."

The most lurid of the Southwestern Ohio city's three daily newspapers at the time, the *Sun* bragged that it beat even the Cincinnati press with that four-page EXTRA detailing the arrest of former Hamilton man Alfred Knapp in connection with the disappearance of his third wife, Hannah Goddard Knapp, who had been missing since before the holidays. Word reached Hamilton that Knapp had gotten married again, an act that confirmed the belief among some of his family that he had murdered Hannah.

The *Sun* received some copy for the story by telegraph from Indianapolis, where Hamilton police captain Thomas Lenehan rode through the night to enlist the aid of local law enforcement to find and arrest forty-year-old Alfred Andrew Knapp for bigamy, as there was no proof of murder yet. The headline was not quite accurate as the confession and a formal charge of homicide were still hours away.

Hannah had been reared in Hamilton by her uncle, Charles Goddard, after the death of her father, his brother William, when she was just a baby. Uncle Charley, a widower, lived alone in two rooms of a little cottage behind the Hamilton Depot on Central Avenue, a station shared by the Cincinnati, Hamilton and Dayton (CH&D) and the Cincinnati, Hamilton

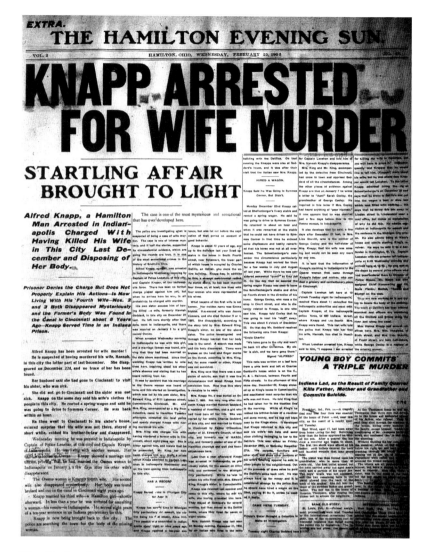

The *Hamilton Evening Sun* was the first newspaper to report on the sensational case of Alfred Knapp, putting out this special morning Extra. *From the* Hamilton Evening Sun.

and Indianapolis (CH&I) lines. Hannah had two half sisters in Hamilton, Bertha Hoagland of Sixth Street and Linda Sterritt of Front Street.

In 1894, twenty-one-year-old Hannah went to Cincinnati to work as a waitress and became acquainted with Mary "Mamie" King, a hostess at Rockwell's Restaurant, who took the girl under her wing and into her home. Mamie was married to Edward King, a heating and ventilation man for

the Pennsylvania Railroad, and they lived in the northern suburb of Cumminsville.

"She asked me to take her and another girl to board and said I could keep house for them," said Mamie, the eldest of Alfred Knapp's three younger sisters.

In August of that year, Hannah was working as a nurse for the superintendent of the Cincinnati Cab Company when she married Alfred Knapp, an ex-convict from various parts of Indiana and Ohio. Knapp's second wife, Jennie Connors, had committed suicide just weeks earlier by jumping in Cincinnati's canal so his marriage to Hannah caused "a great deal of indignation" in the neighborhood where he lived, the *Cincinnati Enquirer* reported. The Kings had advised Hannah against the union and were not happy about it, so the couple settled in a room on Bremen Street, near Twelfth, in the German neighborhood of Over the Rhine.

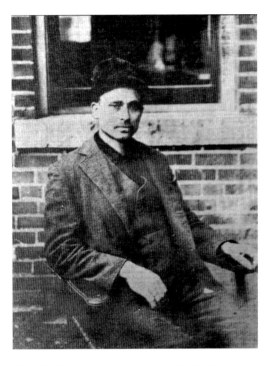

After his first court appearance, a freshly shaven Alfred Knapp gladly posed for the press. *From the* Cincinnati Enquirer.

Alfred did not have a good history with women. He was at times charming and sweet, doting on the women he wooed, but he had fits and a mean streak. He had served at least six prison terms, most of them for larceny. Three terms were for assault, all cases having sexual overtones not specified in the charges.

FIRST WIVES

In 1883, twenty-year-old Alfred Knapp finished serving a two-year term in Joliet Prison and joined his nomadic parents and siblings in Terre

Haute, Indiana. Next door lived sixteen-year-old Emma Stubbs, who would often come around the house to see the Knapp daughters: Mamie, sixteen at the time, and Sadie, thirteen.

"Alfred always had a fascinating way of talking to his sweethearts, and every one of them had the utmost faith in him," Mamie said. "Our family and the Stubbs family were very intimate, and Allie married Emma."

In Terre Haute, the Reverend H.O. Breeden, a Baptist pastor, took Knapp under his wing and tried to reform him. He helped him get a job with a coal hauler and arranged for Alfred and Emma's wedding. There was no reforming the young man, however, and Knapp soon went back to his thieving ways, losing his job after he stole an overcoat from an employee of the coal office. Reverend Breeden helped keep him out of trouble and then gave him a job in the parsonage. Before long, some "lost" money and jewelry owned by the housekeeper turned up in Knapp's possession. Breeden's Christian charity ended, and he pressed charges. Knapp earned another trip to the penitentiary, this one in Jeffersonville, Indiana, and Emma Stubbs divorced him after three months of marriage.

After the twenty-three-year-old Knapp got out of Jeffersonville in 1885, he moved to Marion, Indiana. He quickly wore out his welcome there and moved to Lawrenceburg, where he married Jennie Connors. No one in the family knew how he met her, just that they were married after knowing each other for only three days.

Jennie stuck by him while he went to prison for three more sentences, although it's not clear where she stayed or how she earned a living. Alfred's first sentence while married to Jennie, for stealing a pool table from a saloon in Lawrenceburg, lasted from December 1886 to November 1887. When he got out, he worked odd jobs in Cincinnati. He was laying carpet in a boardinghouse on East Fifth Street when $459 went missing from the proprietress's bureau drawer and some jewelry from a border. It was his second such arrest since arriving in Cincinnati, so he spent most of 1888 in the Cincinnati Workhouse.

His third term was for quite a different crime: assaulting a woman in broad daylight in Burnet Woods in Cincinnati. For that, he went to the Ohio State Penitentiary in Columbus from July 1890 to November 1893.

When he got out of the Ohio Pen, Knapp—now thirty-one years old—sought to fulfill a lifelong fascination and went to work for the circus, the Frank C. Bostock Street Fair Company, joining the show as a general utility man in one of the Kentucky towns across the river from Cincinnati. The

job didn't last long; the performers soon started missing trinkets and articles of clothing from their dressing rooms. Nothing seemed too small or cheap for the taking, let alone purses or jewelry and even brass costume rings. The circus included a beauty show, and the women there began to complain of Knapp's persistent attentions. He came to every performance and on many occasions attempted "undue liberties." When the women turned him away, he would peep into their dressing room between performances. Once the complaints reached the manager, he took one look at Knapp, pegged him as the thief and fired him on the spot.

Knapp went back to Jennie and convinced her to take a job with him in Popcorn George Hand's Circus, she as a cook and he as a general hustler. She didn't like the work, so they quit and went back to Cincinnati, where his father worked as a streetcar conductor on the Mount Adams inclined trolley.

On August 7, 1894, Alfred and Jennie Knapp walked from their Central Avenue home to the offices of the *Cincinnati Enquirer*. He later said he was inquiring about an advertisement for work. She waited outside, he told police and the press, but when he came back, she was gone. The next day, police recovered her body, marred by bruises on her head, lacerations on her face and finger marks on her throat. Police failed to find evidence to support a murder investigation, attributing the abrasions to the body's contact with broken glass on the bottom of the canal and declaring the fractured skull the result of contact with a canal boat. Also, Jennie had a history of being melancholy and in ill health, compounded of late by her husband's inability to work steadily.

"I always thought that Jennie committed suicide," Mamie King testified at the coroner's inquest. "The day before she died she came to my house. I was living in Cincinnati then. I remember that morning well. Hannah Goddard, who boarded with me, and I were having a cup of coffee when Jennie came in."

"I've never been so downhearted in all my life," Jennie said, which is saying a lot considering her husband was already a convict five times over. She told the women that she was about to become a mother and began to cry. "Allie is out of work. What will I do? I have got nothing to take care of my baby with when it is born."

Mamie urged her to not be downhearted and promised to help. Her husband, Ed King, already harbored an inkling that there was something dangerous about his moody brother-in-law. Before Jennie's body was found, he had casually asked Alfred what he thought had happened.

"They'll probably find her near the Wade Street Bridge," Knapp said, which they did. When the patrol wagon later passed by the King house with her remains, Knapp said coolly, "There goes Jennie."

Ruled a Suicide

On August 8, 1894, twenty-three-year-old Joseph Graff sat on the canal bank near the Wade Street Bridge, fishing. His line became snagged, so he gently tugged and pulled on it. It slowly began to give, and he realized he had something with some weight to it. Suddenly, a large object bobbed to the surface: the body of a young woman. Graff tied off his line and ran to sound the alarm.

Coroner Lewis A. Querner arrived on the scene. He noted many marks and scratches on the face, which could be attributed to the body rubbing against the debris at the bottom of the canal.

The remains were identified at the morgue by Alfred A. Knapp as those of his wife, Jennie Connors Knapp, twenty-five, born in Indiana. The husband said that the last time he saw her was 9:00 p.m. the Tuesday previous when he went to the office of the *Cincinnati Enquirer*. He said he stepped into the counting room and left her outside on the sidewalk. When he returned a moment later, she was gone. He told police that Jennie was pregnant and not happy about it because he was unemployed. She had frequently threatened to kill herself unless he got a job.

Martha A. "Mattie" Rice, Knapp's oldest sister, confirmed that Jennie had detested the thought of motherhood and had threatened suicide. She

Jennie Connors Knapp and Alfred Knapp were married only a few days after they met, but she stuck by him through three prison terms. *From the* Cincinnati Times-Star.

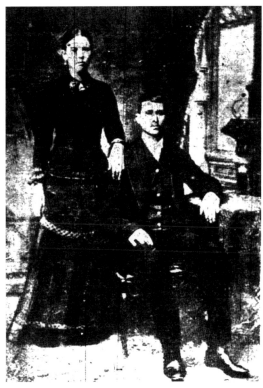

Above: Jennie Connors Knapp's body was discovered near the Wade Street Bridge over Cincinnati's canal. Her death was ruled a suicide. *Courtesy of William Oeters.*

Right: Alfred Knapp's first wife, Emma Stubbs, divorced him after he was given his second Indiana state prison term. *From the Hamilton Sun.*

THE FIRST CELEBRITY SERIAL KILLER IN SOUTHWEST OHIO

An aerial view of Cincinnati at the turn of the century. *Library of Congress.*

thought her sister-in-law was mentally unbalanced and believed she took her own life.

Mamie, who lived at 133 Twelfth Street at the time, said the same, adding that Jennie was once specific enough to have said "for two pins" she would

The Cincinnati, Hamilton and Indianapolis Line

jump into the canal. Hannah Goddard was living with Mrs. King at the time, and she told the coroner the same thing.

After all that testimony, it was obvious to Coroner Querner that it was a suicide by drowning, and his ruling deemed a postmortem examination unnecessary.

Cincinnati at the turn of the century. *Library of Congress.*

Although Mamie warned her boarder Hannah not to do it, Hannah and Alfred married six weeks after Jennie's death. Mamie and Hannah remained close even as the newlyweds moved around Cincinnati, struggling to earn a living and escape the stigma created by their hasty marriage. Alfred and Hannah moved to Hamilton for a brief time and then finally ended up in West Indianapolis in the summer of 1895.

Bessie Draper

During the summer of 1895, thirteen-year-old Bessie Draper came to West Indianapolis from Terre Haute to live with her aunt. Bessie wanted to get a job, maybe as a "cash girl," she said, so she could send money to her struggling single mother.

In the meantime, she helped her aunt with chores. On the afternoon of August 29, she went to the washerwoman's to pick up some laundry.

On the way home, she met a friendly young fellow on South West Street pushing a wheelbarrow with a dresser tied to it. He was well dressed, except

for an oddly shaped patch on the shoulder of his shirt. He struck up a conversation, telling Bessie that he was looking for a "nurse-girl" for his sister's children and asked if she would be interested in the job.

Bessie was indeed interested but wanted to get permission from her aunt. Her aunt told Bessie that she could decide for herself, so she caught up with the man and followed him to his house. She refused to go inside with him and waited at the gate while he took the dresser off of the wheelbarrow and through the front door. She thought that Knapp was an honest man, but this was shortly after the murder of little Ida Gebhard not far from there, and her uncle had just been talking about that the night before. She remained wary.

When the man emerged from the house, he took her on a circuitous route through the streets and alleys of West Indianapolis, and her wariness evolved into fear. He led her down an alley near Wisconsin Street that led into a stable. When Bessie saw that it was a dead end, she turned and ran the other way. The man ran after her, caught up and grabbed her by the throat. She managed to break loose and scream as he threw her to the ground. Another man saw what was going on and came toward them as she regained her footing and resumed running. Her assailant threw stones at her until she disappeared.

Sheriff Al Womack set up a sting with the help of Annie Buchanan, the matron at the police station. He instructed Bessie to walk past Knapp's house and if she saw the man who assaulted her, to signal Mrs. Buchanan, stationed a few houses down. As the girl walked toward the house where the man took the dresser, he came outside and approached her. As instructed, the girl looked back at Matron Buchanan, who hustled to her rescue as another officer waiting in a nearby alley placed Alfred A. Knapp under arrest for attempted rape. Knapp was identified by the girl, the family he bought the dresser from and the German man who interrupted his crime. The incriminating evidence was a peculiarly shaped patch on Knapp's shoulder that the girl described and which was found on the shirt when a deputy waiting in the alley arrested him. Hannah and Knapp's mother were there every day for the three-day trial as the prosecutor pointed out Knapp's already impressive police and prison record. Indeed, the resulting trip to the state penitentiary—a ten-year sentence—was his sixth.

Knapp was angry about the conviction, proclaiming his innocence and dramatically swearing an oath of vengeance at Sheriff Womack, his deputies, the prosecutors, the judge and all the jurors, naming twenty-two men.

He served seven years of his sentence for the assault on Bessie Draper and was released in June 1902. He was forty years old and had spent most of his adult life behind bars for petit larcenies and assaults on women and girls.

Sheriff Womack was irritated that he was not apprised of Knapp's parole, since that would have explained the fire that destroyed his barn and caused $8,000 of damage in fine horses and Hereford cattle (nearly $200,000 in today's dollars). A week later, the barn of one of the jurymen, Omar Boardman, was also set on fire, causing $3,000 in damage. Both men blamed Knapp but did not have any evidence against him.

"A Thriftless, Low-Life Loafer"

While Knapp was in prison, Hannah again lived with Edward and Mamie King in Cumminsville. She became quite popular in that Northern Cincinnati suburb, and the Kings came to love her as if she were their own daughter. When they learned Alfred was about to be released from Michigan City Prison, Mamie begged Hannah to stay and make her home with them, but she wanted to be with Knapp. Since Knapp and Ed King didn't get along well, Hannah moved in with her Uncle Charley in the summer of 1902 to prepare for her husband's release.

When Knapp got to Hamilton that June, he worked various jobs as a common laborer at a mill, for the railroad and at more than one stable. He also drove a coal wagon. None of the jobs lasted very long. He liked to tell people that he had been an acrobat and trapeze artist in the circus, where he made $100 a week as a headliner.

Shortly after Knapp arrived, the couple called on Linda Sterritt, Hannah's half sister, whom she hadn't seen in nearly four years. Sterritt was amazed at how much the girl had changed. She seemed thin and distracted. "I readily realized that she was a very unhappy woman," Sterritt said. "My sister was a woman who was easily influenced, and she was only putty in the hands of Knapp. She called at my house about every two weeks, and I saw that she was worried. I never asked her if she was abused by Knapp, and she never told me, but I knew that he worried her, as he was a man who could not be trusted with a ten-year-old girl." He was, she said, "a thriftless, low-life loafer."

John Cable worked with Knapp at Carr's Mill and lived with his brother and mother in the same house as Charley Goddard. The Cable brothers were from Kentucky and had not lived in Hamilton very long. Knapp tried to get Cable to help him "take care" of two women named Graham that he didn't like.

"Along September," Cable said, "he proposed to me that I go with him some night and together we would do away with two women he didn't like in this house, as he put it, 'the two women in the other side of the house from me.' I told him I'd die before I'd help him or anyone else do such a thing." Cable said that he recoiled in horror at Knapp's suggestion, but Knapp just smiled at him.

"Why, what's the difference?" Knapp asked. "Nobody will ever know anything about it anyhow. I am going to do up my wife one of these days because she isn't treating me right."

Cable said he had seen nothing of Hannah Knapp since before Christmas and was present for a time when Knapp was disposing of her belongings. "I believe he killed her, for why didn't she wear her pretty white collar and gold pin away with her if she went visiting?" he said.

That incident provided a valuable clue to Knapp's inability to keep a job for long (when he bothered to show up at all). Conversations like this and other shenanigans eventually led to his dismissal from the mill. Carr would later recount incidents in which Knapp, "in pure wanton malice," threw a heavy chisel from a fourth-story window of the mill toward a man and a woman walking below on one occasion and, on another, a heavy piece of railroad iron toward a passing woman.

Knapp stayed with Hannah at her uncle's house for a while, but he didn't seem to like the close quarters. The couple may have moved to Indianapolis for a short time. In October, Hannah consulted a lawyer there named Lemon Reinhold, asking him to begin divorce proceedings against Knapp. She said that Knapp had made threats, and she feared her husband would murder her. Reinhold told her that she hadn't lived in Indianapolis long enough for a divorce.

By November 1902, they were back in Hamilton, and Knapp was driving a coal cart for Harry Jones, a Lindenwald coal dealer. The couple rented upstairs rooms at a house on South Fourth Street owned by Charles Datillo, an Italian immigrant and fruit merchant who lived around the corner on Cottage Street, not far from the Hamilton Depot.

Hamilton mayor Charles Bosch lived next door to the house on Fourth Street and was sitting on his porch one day when Charley Goddard brought Knapp and his wife over for introductions. Bosch, who had been Hamilton's mayor for ten years and was so popular that he had recently been reelected in spite of a scandal over his administration's bookkeeping practices, said every time Knapp had a chance to drive his coal wagon past the house he would give some signal for Hannah to come to the front window and wave.

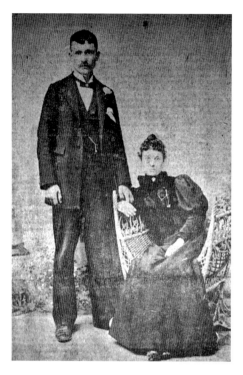

Wedding photo of Alfred Knapp and Hannah Goddard. *From the* Cincinnati Commercial Tribune.

If she did not appear, he would stop the team, dismount and hasten into the house, returning a moment later with a big smile on his face. It was a regular enough occurrence that it became something of a joke among the older married couples in the neighborhood and led people to believe that Alfred Knapp was a sweet, if odd, man, devoted to his young wife.

On December 19, 1902, Mamie King wrote Hannah a letter inviting the couple to the King home for Christmas dinner. Hannah wrote back thanking her but declined. Alfred had been sick and out of work, and she did not feel they could afford the expense of the trip.

On Sunday, December 21, Hannah and Alfred visited her Uncle Charley with some other relatives from Cincinnati and a Mrs. Cline. Later that evening, the woman who occupied a room next to the Knapps in the Datillo house said, "I heard them singing a song together. I don't know what they were singing, but I heard them."

That was the last anyone heard from Hannah.

"Where Is Hannah?"

Henry Shollenbarger was likely not very pleased to see Alfred Knapp walk into his livery stable early Monday morning. He had given Knapp a job back in the summer, but it only lasted a few weeks. Knapp didn't know a thing about horses and couldn't learn. Shollenbarger told Captain Lenehan that Knapp was somewhat "queer," mentally weak to the point of simple-mindedness.

Knapp wanted to rent a spring wagon. He said he was going to drive to Symmes Corner but returned in less than an hour. When he got back to the stable, Shollenbarger remarked he could not have driven to Symmes Corner and back in that time. Knapp seemed to think Shollenbarger was accusing him of running the horse too hard and testily shot back that the horse was not at all overheated and never said more about where he had been.

George Cooley, a tinsmith at a shop on Court Street and the nephew of Hannah's half sister Linda Sterritt, saw Knapp leave the Shollenbarger stable in the wagon. Knapp waved and told him he had some stuff to haul away and then drove up Fourth Street toward his home.

Before he left Hamilton, Knapp left a note at Goddard's house: "Uncle Charley: We have gone to the city and won't be back until after Christmas. My sister is sick and we have gone there. Signed, ALFRED."

That afternoon, Edward King stood out by the front gate and watched Alfred Knapp walked toward his house on Lakeman Avenue in Cumminsville from the direction of the traction line. King knew by Knapp's gait that something was amiss. He still had niggling suspicions about what had happened to Jennie but kept them to himself for the sake of family harmony.

"When he asked me if Hannah had not called at my house that day, my suspicions were confirmed," he said later. "I made up my mind then and

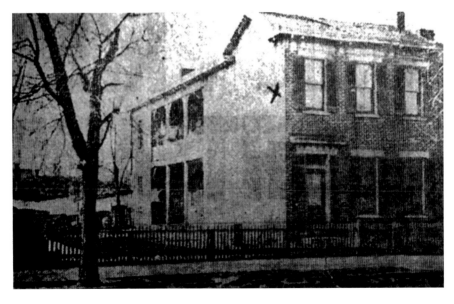

Alfred Knapp strangled Hannah Goddard Knapp in the room marked with an "x" in this Fourth Street house, known as the "Datillo house," owned by a Hamilton produce seller. *From the* Cincinnati Enquirer.

there to prosecute him if he was guilty of the murder of Hannah Goddard, for a better woman never lived."

"Hello, Ed," Knapp said.

"Hello, son," King said. "Where is Hannah?"

"Hasn't she been here?"

"Why, no," King replied, trying to act casual. "When did she leave home?"

"I got a note from her," Knapp said, "saying that she was coming to town on the traction line, and I thought I would come after her. I supposed she was here."

"No," King said. "She has not been here, but come in and sit down. She may come any moment."

Inside, Knapp asked King to operate the Victrola. King sensed an edge of nervousness around Alfred's calm appearance. As he played the phonograph, King saw guilt in Knapp's every gesture, even when he listened to the music with a faraway look on his face. He played along with Knapp's story and asked him to stay for supper.

"I watched Knapp while he was eating supper, and the more I watched, the more satisfied I became of his guilt," he would testify. "I decided to charge him with the murder when he was not expecting it."

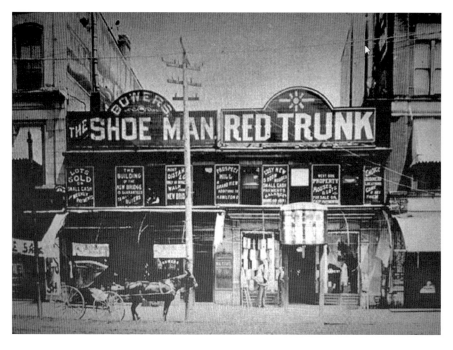

From the Red Trunk store, Alfred Knapp purchased an old box in which to put his wife's dead body. *Lane Library Cummins Photo Collection.*

After supper, he spied an obviously troubled Knapp deep in thought, his fingers twitching nervously and his eyes fixed on the floor.

"Al, I believe you've got another Jennie case on your hands," King said.

Knapp gave a start but recovered himself and said, "What makes you mention her name?"

"Because I believe you killed her, and now Hannah, too."

"You're wrong, Ed," Knapp said. "I don't know where Hannah is, and I don't know why she left home."

King said nothing more, afraid that panicking Knapp could put his wife and child in danger. But he watched Knapp's every move and invited him to stay the night so he could watch him some more, enlisting the aid of his father, who lived in Hannah's old room. Knowing that Knapp had the habit of talking in his sleep, King put his brother-in-law in a rollaway bed in his father's room, instructing the old man to sleep easy and take note of anything Knapp said in the night. Knapp rolled and tossed and muttered unintelligibly, but the elder Mr. King was unable to report any specific words.

King wanted to continue keeping an eye on Alfred and invited him to stay through Christmas. Alfred said he would come back for Christmas but had to go to Hamilton first.

A Definite Clue

Back in Hamilton, Alfred Knapp sold his wife's two hats and some dresses to the Datillo women, telling them his wife had left him. He sold his carpets, furniture and other household items, along with his wife's clothing, to other people in the neighborhood. Out of the proceeds, he paid his landlord seventy-one dollars in back rent.

Knapp also paid a call to Hannah's half sister Linda Sterritt.

"Have you heard the latest?" he asked abruptly as he came into the house.

"What is it?" she replied.

"Hannah has disappeared," he said without any sign of concern.

"What do you mean, Alfred?" asked Sterritt.

"A little boy came to the house with a telegram saying that Mamie was sick in Cincinnati," he said, explaining that Hannah left to go there but never arrived, and he knew she would never be coming back. He said he was selling all her things and going to Cincinnati and then to Indianapolis.

"Will you be back here?" Sterritt asked.

"Oh, yes," Alfred said, lowering his voice and putting on an air of secrecy, "but I will be disguised so no one will know me. I was a detective in Indianapolis for some time and I will get myself up so my own relatives will never guess who it is."

Knapp visited for about fifteen minutes, and that was the last time Sterritt would see him until his arrest.

"I never liked his appearance," she told reporters, "and he was forever changing positions. Every time he came to our house he was working in a new place."

Tony Datillo, the produce man's son, went to Knapp's room that evening and found him crying and shaking with emotion. Between sobs, he managed to say, "My wife has left me and will never return. I can't live without her. My life will be so lonely." Datillo tried to comfort him, telling him that Hannah would come back.

"I know she will not come back," Knapp said.

The next day, Alfred returned to the Kings' house and told Ed King that he'd sold all of his wife's clothing.

"What did you do that for?" King asked.

"Well, she's gone where she don't need any clothes," he said.

Knapp stayed two more nights with the Kings, through December 26, but refused to sleep in the folding bed again, opting instead for a chair near the kitchen stove. This time, King kept watch himself, noting how Knapp's fists clenched in his sleep as he muttered and struggled, his teeth snapping at times like a defensive animal. The longer Knapp stayed, the more King feared for the safety of his family. The day after Christmas, King made it clear that he needed to return to work but would not leave Knapp alone with Mamie and the baby. Knapp took the hint and told his sister that her husband didn't want him there and that he was returning to Hamilton.

"I told my wife I was suspicious, but she begged me not to do anything that would bring further disgrace on the family," King said. "When I told her I had determined to investigate Hannah's disappearance she made me promise that I would do nothing to cause notoriety until I had some definite clue to work on, otherwise I should have gone to work on the case at once."

Before Knapp left, he stole King's revolver and went to West Virginia, where he sold it to a barber. He then went to Indianapolis to visit his parents and help his father haul ashes for a while. On that trip, he met Anna May Gamble and her foster father, George Owings, who lived on the same block.

The Cincinnati, Hamilton and Indianapolis Line

On January 7, 1903, Knapp wrote a letter to Hannah's aunt Sarah Cooley, grandmother of the tinsmith George Cooley, to ask if she had heard anything of "poor Hannah." Meanwhile, King stewed, determined and ready to launch an investigation into Hannah's death but keeping true to his pledge to his wife. When his mother- and father-in-law came calling on Sunday, February 22, he felt like he had his proof.

Cyrus and Susannah Knapp had recently moved to Cincinnati from Indianapolis at the urging of their daughter Sadie Wenzel, who had rented them a candy store to run.

"They called at my house and asked me if I had heard that Alfred had married again in Indianapolis," King said. "I answered in the negative."

They explained that they had a letter from Alfred announcing his marriage to Anna May Gamble of Indianapolis. Alfred's mother asked King if any search had been made for Hannah. King believed that remarrying was the same as admitting to Hannah's death.

On Monday, King received an unexpected visit from Charley Goddard, who said he was "firmly convicted" that Hannah's body was dumped in the Great Miami River.

A Trip to Hamilton

After hearing from her parents that Alfred had married again, Mamie gave Edward King permission to launch the investigation he'd long been considering. Hannah had once confided to Mamie that she was afraid Alfred might turn on her someday and try to hurt her. If that time came, she said she might have to hide out for a while so it might seem like she had disappeared. She promised when that time came she would get word to Mamie in secret so that she wouldn't worry.

"I expected to hear from her, but as time sped on and no word came the terrible suspicion grew on me," Mamie said. "I urged my husband to do something to find her. I could not bear the thought of letting the mystery rest and never know what became of her."

Before going to Hamilton, King enlisted the aid of his friend Eugene Rankin, a detective with the Pennsylvania Railroad.

"I went to him because he is my friend, and I knew that if I was mistaken in my conclusions that he would keep it quiet," King said. "It was with the hope of finding Hannah Goddard alive somewhere in Hamilton that I went there with Mr. Rankin to begin the investigations."

On Tuesday morning, King and Rankin called on Sadie Wenzel and Knapp's parents at the candy store, asking to see the incriminating letter about Alfred's marriage. Sadie refused to talk to them or let her parents say anything more and said the letter did not exist. It would later come out that Sadie had burned it.

"You should have more sense than to take this up against Alfred," she said.

"Something must be done," King said. "The suspense is unbearable. If he is innocent, we need to know that, and if he is guilty, the law will have to take its course."

Then King and Rankin went to Hamilton, first to the Datillo house, where neighbors told them of quarrels between Alfred and Hannah Knapp and how Alfred sold off their belongings and Hannah's clothing right after Christmas. They went to some of his former employers, and the Shollenbargers told them of the rental of the spring wagon on December 22.

King and Rankin then stopped in Lincoln Lenehan's saloon near the Hamilton Depot, asking for directions to the house of Charley Goddard and to have a drink or two, apparently not their first of the day. The two seemed rather suspicious to the saloon keeper, who was the brother of the captain of police—especially King, who was around fifty years old and had a long, dark mustache and was wearing "a wig that is one of the most ludicrous sights imaginable," the *Sun* reported. King seemed like he'd had a few drinks and was trying to act mysteriously, saying he knew Hannah Goddard was dead. Charley Goddard wasn't at home, but they met a neighbor, O'Brien, who took them to visit George Cooley, a tinsmith and Hannah's cousin, and then went to the banks of the Great Miami River, south of town.

O'Brien, King and Rankin spent the late afternoon searching for signs of the missing woman, but the river had risen and fallen twice since her disappearance. They went back to the saloon and were greeted by a beat cop Lincoln Lenehan had summoned. After hearing King's story—reluctantly, since King was enjoying his long-awaited investigation and apparently not ready to give it over to the authorities yet—the beat cop took them to see Captain Thomas Lenehan, the barkeeper's brother, and the investigation officially began.

Captain Lenehan heard their story and followed up to confirm some of their evidence: that Hannah Goddard Knapp had indeed been missing for over two months; that Alfred had told people she had disappeared; and that he had rented a spring wagon to haul some of his belongings around at the same time. Lenehan was sympathetic to their cause. There was enough suspicious behavior on Knapp's part—taking a new wife, for instance, when

the previous one was still missing—to warrant a trip to Indianapolis to track this fellow down.

King warned Lenehan to "go slow" on the case. "But if you do arrest him, don't tell who gave him away," King said. "He would kill all of us."

"Are you mad at Knapp for some reason?" Lenehan asked.

"He stole my revolver," King answered.

Lenehan thanked King and Rankin for their effort in bringing the matter forward and then sent them back to Cumminsville before catching the 10:00 p.m. train to Indianapolis. Even if Hannah had indeed simply left her husband, there was no record of a divorce, and they could at least get Knapp on a bigamy charge.

Lenehan arrived in Indianapolis about 1:00 a.m. The police there knew Knapp well because of his previous crimes, and it didn't take long to find him. Around 4:00 a.m., Lenehan and Captain Kruger, who would be Chief of Police Kruger by year's end, went to Indiana Avenue where Knapp was living with his fourth wife, the former Anna May Gamble, in a dark and dingy two-room basement apartment that had once been a paint shop. Knapp had told Annie that Hannah died in Hamilton. She didn't suspect that it was at his hands.

When Annie was six years old, she was taken from the College Avenue Orphan Asylum by George Owings, a veteran of the Civil War, who received a monthly pension of twenty-eight dollars. Owings had served with the Twenty-sixth Indiana Infantry and participated in the Battle of Spanish Fort in Alabama. It seems odd that a bachelor would have been able to adopt a female child, but if there was a Mrs. Owings at one time, none of the newspapers mentioned it.

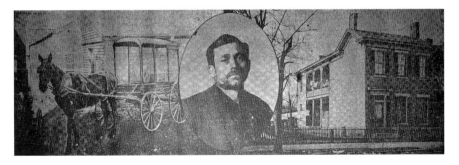

The *Cincinnati Commercial Tribune* published a triptych showing the wagon Alfred Knapp used to carry his wife's body to the Great Miami River, a portrait of the strangler and a photo of the house where he lived with Hannah Knapp. *From the* Cincinnati Commercial Tribune.

Owings paid for the couple's marriage license and officiated as Knapp's best man at the wedding.

"The wife is very weak mentally," the papers reported, and their marriage was the result of the efforts of the ill and aged Owings to secure a husband for the weak-minded girl. Knapp may have been corresponding with Owings, who lived on the same block as Cyrus and Susannah Knapp, for several months, even while Hannah was still alive. But he did not meet Owings and Miss Gamble until the Friday before New Year's Day. They were married on February 3.

Knapp never worked while in Indianapolis. The three of them lived off Owings's pension in a filthy, dank, two-room cellar apartment, with a second bedroom created by a curtain hanging across the main room.

"I'm the Man"

Even at 4:00 a.m., Alfred A. Knapp seemed excited about something when Kruger knocked on his door. It was his jurisdiction, so Lenehan stood back until they would have the suspect safely in jail. After offering apologies for the early hour intrusion, Kruger asked, "Does a man named Knapp live here?"

"I'm the man," said Knapp. The man had a swarthy complexion, penetrating brown eyes and coal black hair showing spots of gray on top. He had not shaved for several days.

"Where is your wife?" Kruger asked.

"In the house," Knapp responded.

"When did you marry her?"

"February 3," said Knapp, showing Kruger the wedding license.

"Where is your Hamilton wife?" Kruger asked.

"I don't know," Knapp said.

"Well, we'll arrest you both and find out," Kruger said.

"You will have to prove it," Knapp said.

Lenehan's goal was to bring Knapp back to Hamilton without going through the red tape of extradition, so he had to get him to come willingly. When he questioned him at the Indianapolis police station, he didn't mention murder to make Knapp think he was wanted on a bigamy charge, but he still wanted to get what information he could about Hannah's whereabouts.

"When did your wife go away?" Lenehan asked.

"Sunday morning a young fellow came to the door and told her my sister was sick in Cumminsville. He said that a telephone message had come to the depot for her. I took her down to the traction office and put her on a car. I kissed her goodbye," said Knapp.

"Where is she now?" Lenehan asked.

Knapp responded, "I don't know."

"How was she dressed?"

"She had on her old dress and a fascinator," a type of small fashionable hat.

"We're going to have to arrest you for bigamy," Lenehan said, "and take you back to Hamilton."

"Well, if they want to prove bigamy on me, they'll have to find Hannah," Knapp said.

"I guess we can find her," Lenehan said.

"I guess you won't find her," Knapp said.

That was as good as a confession for Lenehan, so he let it end there until he could get Knapp back to Ohio. They locked him up in the Indianapolis jail until the next train. Kruger reported that Knapp said he had more information the police would be interested in but would not say what it was. Kruger asked him about his second wife, Jennie. Knapp just leaned back in his chair with an air of self-satisfaction and said that Jennie had committed suicide in Cincinnati's Miami and Erie Canal.

"I know she was dragged from the canal," Kruger said. "I'm just curious about the wound on her head."

"Well," Knapp said, seemingly disconcerted, "I thought it was made when she fell into the water."

"I also wonder about the fingerprints on her throat," Kruger said.

"I don't know about that," Knapp said, suddenly squirming in his chair. "I left her standing in front of the newspaper office when I went in to place an ad. When I returned, she was gone."

Lenehan left Indianapolis with Knapp at 8:00 a.m. Wednesday

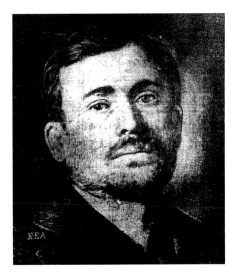

This artist's rendering of Alfred Knapp, taken from a photo after his arrest, was widely distributed to newspapers across the Midwest. *From the* Hamilton Evening Democrat.

morning on a train, due to arrive back in Hamilton at 10:40 a.m. Knapp complained that the handcuffs were too tight, but Lenehan noticed how strong his hands appeared and declined to loosen them.

On the ride, Knapp turned to Lenehan and said, "You can't convict me until you find the body."

Lenehan spotted a cluster of blue uniforms as they pulled into the station, police officers who had been ordered there by Director of Police Charles E. Mason. Behind them was a crowd of several hundred people who had turned out to see the man whom the *Evening Sun* had already accused of murder disembark from the Indianapolis train.

CONFESSION UPON CONFESSION

In a late-night fifth edition, the *Evening Sun* bragged that those early four-page EXTRAs had been for sale at the depot "for quite some time" before Captain Lenehan and Knapp got back to Hamilton. Bremer, "the hustling news agent" at the depot, said he sold the papers like hot waffles, and dozens of newsboys fanned out with bundles across the county on the traction lines and trains to outlying villages and cities. The first edition of 6,200 papers sold out immediately, and another 1,000 were printed. By 1:00 p.m., the paper had totally sold out. It would print three more editions that day and three the next. By way of comparison, the population of Hamilton at the time was around twenty-four thousand, out of fifty-seven thousand Butler County residents.

So the word was out, and a crowd of two or three hundred people gathered at the Hamilton Depot to see the prisoner get off the morning Indianapolis train. The city had not yet gotten over the shock of Samuel J. Keelor's bloody murder of his wife, Bertha, just ten days earlier—the first indictment of first degree murder in Butler County since 1884. And in September, crowds had gathered ominously around the Butler County Jail taunting the farmer Joe Roth, suspected of the attempted abduction of the little Motzer girls. But this new story of a missing wife, a Hamilton girl presumed murdered by a "thriftless low-life loafer" from out of town, had the potential for violent indignation. Knapp was not yet charged with a crime other than bigamy, and there had yet to be a more serious crime proved, but that didn't stop popular interest.

With Lenehan close behind, a handcuffed Knapp stepped off the train, keeping his eyes downcast as he walked through the crowd to the patrol wagon with an almost imperceptible quiver on his lips. He sat down near the driver's seat of the wagon and, without looking directly at Lenehan, said, "Old Charley looks like he's been on a jag or been sick," referring to his wife's uncle.

"I did not notice him," Lenehan said.

"Well, he looks bad," said Knapp. During the ride to the police station, Knapp hardly lifted his eyes.

Police had already begun the search for the missing body, examining all the thickets and groves along the river south of the city. Taking a cue from Charlie Goddard's statement to Ed King that he believed Knapp had thrown her in the river, police carefully examined every spot where a body might be disposed. Although Knapp said it contained clothing, police were operating under the assumption that when they found the box, they would find the body of Hannah Goddard Knapp. If the box had made it into the water, it could have gone a long way in two months, or it could have sunk right there. It was impossible to know.

Day Clerk Weber at the jail taunted Knapp, asking him if he wanted to see his wife, perhaps trying to trip him up.

"Yes," Knapp said. "I would like to see her if she is alive."

"I'll bring her in," Weber said.

"Alright, I would like to see her," Knapp said. "But I think my wife is dead, and I suppose I shall go to the chair for it."

The newspapers were quick to jump on the insanity aspect, even on the first day of coverage. The *Hamilton Evening Democrat* wrote of Knapp's "insane desire for the blood of women" and quoted "some man," saying, "I believe this man had a craze, an insane appetite after the blood of women as evidenced by his bespoken desire to kill those Graham girls and later the declaration of a wish to slay his wife." The *Sun* called him "a moral pervert and the finest specimen of a degenerate that has ever been seen in Hamilton," in "the opinion of a physician who has made a special study of physiognomy and criminology."

"His receding forehead shows lack of intellect, and there seems to be a terrible lack of some portion of his brain necessary for a well-balanced mind," the anonymous doctor said. "To express the idea in the vernacular, he 'has a screw loose.' I have talked with this man and his manner is certainly that of a degenerate…To a man with any idea of intellect, Knapp is loathsome."

Confession Upon Confession

The First Sweat

Once they got Knapp securely behind bars, police didn't seem to know what to do with him. Intent on finding the body, they didn't question him for several hours. He sat alone in his cell until Mayor Charles Bosch set out to put some pressure on the prisoner before he had much time in quiet seclusion to make up more lies to cover his nefarious deeds. Until then, Bosch had considered Knapp a rather likeable and sweet fellow, so his arrest was deeply disconcerting.

"Bring him to my office now," Bosch told police officials. "Give him no peace until he confesses or at least tells what he knows."

At about 2:00 p.m. on Knapp's first day back in Hamilton, the "sweat" began in the mayor's office, intense questioning by the team of Bosch, Director of Police Charles Mason and Police Chief Gus Kuemmerling in the hope of making the prisoner nervous enough to break down and confess his crime.

Knapp maintained "an air of mild bravado" during the three-hour grilling, the *Sun* said, though his distress was apparent. Great beads of perspiration glistened on his brow, and he shifted in his chair, eyeing his interrogators furtively. He would at times show signs of weakening, only to rally himself before he would give too much away. He continued to deny disposing of his wife, sticking to the story that he took her to the traction line on December 22 and had not seen her since. He did not explain his action in marrying the Gamble woman except to say that he didn't know it was wrong.

During the "sweat," Knapp's name also came up as a possible perpetrator in another case that attracted considerable local attention back in September, an attempted abduction of two little girls, Hattie and Stella Motzer, ages six and almost five, a crime for which the police already had a man by the name of Joe Roth in custody.

One of the girls had identified Roth as their assailant. Joe Roth steadfastly maintained his innocence, and the physical resemblance between Roth and Knapp was "most marked," the *Sun* reported. Some started wondering if Roth might be telling the truth.

Although much of the excitement about the Motzer case had died down, Joe Roth was still jailed for the crime and about to go to trial soon after Alfred Knapp's arrest, even though the evidence against him was slim. With Knapp in custody, police now had new hope for really solving that case instead of pinning it to the most likely suspect they had. So during the Tuesday afternoon "sweat," Director of Police Mason asked Knapp what he knew about the Motzer case.

"I was right in the neighborhood when the assault was committed, but I did not know anything about it until I read it in the papers," Knapp said.

"Where were you in the neighborhood?"

"I was at Dr. Krone's office."

"What were you doing there?"

"I had the stomach ache and went there for treatment. The doctor prescribed for me, and I went away."

"Did you pay the doctor?"

"No. He charged the bill."

They called up Dr. Krone to verify, but Krone said that he did not see anyone the night of the assault. He said that Knapp had been in his office before but had not been there since last July.

Anna Motzer, the girls' mother, said that shortly after the attempted abduction, she was visited by a strange man who said he was a detective and showed her a badge that was obviously a novelty. She warily answered his questions and then sent him away. He assured her that he would be keeping an eye on things but that she would not recognize him because he would be in disguise.

Police and press both noticed that there was a distinct similarity between Knapp and Joe Roth, both short, slim, swarthy men. Plus, there was a distinct similarity to what he told Anna Motzer about being a detective in disguise and what he told Hannah's half sister Linda Sterritt. No matter how much Knapp would deny his involvement, the attempted abduction of the Motzer girls would cloud his case to the final day.

In the meantime, police officials began the process of investigating the deaths of Knapp's other two wives. The fact that Knapp had a long criminal record, having served a lot of time in different prisons mostly for assaults on women and children, they were equally confident that Knapp may have been guilty of one or two other murders or assaults as well.

The "sweat" at the police station lasted three hours. Toward the end, Butler County prosecutor Warren Gard and Mason left the room to begin inquiries into Knapp's past, and it seemed to Bosch that Knapp started speaking more freely when they were gone.

"Would you talk to me alone about it?" Bosch asked.

Knapp hesitated, started to talk and then hesitated again.

"What if I wait until morning, will you tell me then?"

"No," Knapp said, resigned. "I'll tell you now."

Knapp told Bosch that he killed Hannah at about 5:00 a.m. on December 22, but that he did not know why he did it. At first, he hinted that he may

have killed one of his other wives but then denied murdering anyone but Hannah. This was becoming Knapp's favorite game: beg the question, decline to answer.

"This Confession Will Not Ease My Mind"

The *Evening Sun* and other newspapers printed Knapp's confession to Mayor Bosch in great detail:

> *On the morning of December 22, without one word of quarreling or anything to prompt the act, I caught my wife by the throat and choked her to death. I have felt very bad about it, I cry every time I think of poor Hannah. She was a good wife, I guess, but I strangled her. I choked her to death. Oh, I don't know why I did it. I guess I didn't know what I was doing. She was a mighty good wife and a good woman. She was good to me. I don't think any man had a better wife than Hannah. I choked her, though.*
>
> *I seemed to be in a doze at first. I seized her as she slept and did it as soon as I awoke. When my fingers once closed down on her throat, I could not let go and I held on my fingers sinking deeper and deeper into her neck. When I awakened I found that I had my hands about her throat and that I had almost choked her to death. Her eyes were rolling and she was gasping for breath and I was afraid to let go. I don't know why I did it, but I could not let go 'til she was dead.*
>
> *I came to myself, and realizing what I had done, I sought to hide the body. I arose and dressed and went out to find a box. It was dark yet and must have been somewhere between five and six o'clock. I went up town and having worked at Shollenbarger's I went there to get a rig. I knew the boys there. I got a shoe box, one of those big shoe boxes in which the shoes are shipped to the stores, I bought off an old man for 15 cents in the alley back of the Red Trunk. I went to the Racket Store and bought five cents' worth of eight penny wire nails.*
>
> *Before I put Hannah's body in the box, I laid a piece of rag carpet in the bottom. She had nothing on but her nightgown and stockings at the time. The box was small and I had to double up her legs and force her in. I laid several thicknesses of carpet over the body. I put three of the nails in each end of the box lid and after some thought decided to haul it away. Where I hardly knew.*

At 7:20 o'clock I tried to load the box in the wagon, but I could not. I called a boy who was passing by. He was a pretty good-sized fellow, and I gave him a nickel to help me carry the box down stairs. I then drove south, not knowing where I was going. I took the box down to Lindenwald, then drove the wagon right west from the Shuler & Benninghofen Mill and went to the river where the River Road turns and begins to follow the bank of the canal and when about two miles below the city when I reached a place where there are a lot of trees and a steep bank, I stopped and took the box out.

In 1934, the *Hamilton Evening Journal* published a recap of the Alfred Knapp case with this evocative illustration. *From the* Hamilton Evening Journal.

Confession Upon Confession

I only had time to roll it into the bushes when I saw a mail carrier coming in a wagon. I got back in the wagon and drove on slowly and when he had passed me drove back and rolled the box into the river. There is a steep bank there and I threw it over the bank in the old "sucker hole." After I threw the box in the river it did not sink. I saw that it remained on the water. Of course, I didn't stay to watch it. As soon as the carpet got soaked and water got in the box it sank. I just dumped it and drove away. I was afraid that someone would see me. That's the reason I hurried back.

After that I came up town. It was about 9 o'clock. I waited around until 1:15 when I got a traction car and went to Cumminsville. When I got to Cumminsville I went to King's house and asked for my wife. They said they had not seen her. I stayed at the Kings' house that night and then came back to Hamilton.

I sold her hats and dresses and returned the furniture to Lowenstein & Loeb. They came and got the stove. It was still red-hot but they carried it out anyhow. I went back to Cincinnati and spent Christmas with the Kings. I came back to Hamilton the Monday after Christmas and then went back to the Kings and stayed there until the last day of the year, when I went to Indianapolis.

I got married there, and here I am now.

Ever since I committed the crime I have not been able to sleep and have been sorry that I did it. She was one of the best of women and was always good to me. We never quarreled and I had no reason for killing her.

This confession will not ease my mind. Nothing could do that except to have her back again.

I don't know why I did it.

I suppose I will have to go to the electric chair for this job.

The Confessional Ride

The mailman Alfred Knapp saw as he rolled the box containing his dead wife's body toward the Sucker Hole turned out to be Charles Misspaugh, Rural Carrier No. 4, who remembered the incident.

"I was within twenty-five feet of him that day," he said, "and I noticed him sitting on a box in a wagon standing by a clump of willows near the Sucker Hole. He rather turned his head away as I passed, but still I got a good look at him. He did not drive away while I saw him, but remained

where he was as long as I noticed him. I wasn't sure about [his] recognizing me as I was in my closed wagon when I passed."

The Sucker Hole is seldom visited in the winter but is just across from "the Island," a favorite spot for fishing camps in the summer. The east bank of the river is tree-lined with projecting roots where the river has washed the earth away. The police seemed to think that the box in which the body was concealed may have lodged among these roots and might have been there yet.

Knapp offered to take the mayor to see the spot, so the entire interrogation team loaded into a pair of police buggies and went on a "confessional ride" with Knapp down to the river.

Knapp rode in the front buggy with Police Chief Gus Kuemmerling and Mayor Charles Bosch. Although they acted quickly and secretly, a pair of sharp reporters noticed and hastily hailed a cab, following close behind the official vehicles. Knapp navigated, pointing out the route he had taken on that fateful day.

By a coincidence that was either incriminating or merely strange, the path he took was the same route the bloodhounds took when they were on the trail of the alleged assailant of the Motzer girls back in the fall: down Water Street to Wood, east on Wood to Second and south to the road through Peck's Addition. But the parade of police and press buggies then continued further toward the river, traversing about two hundred yards into a remote area where the road, overgrown with thorn bushes and small trees, was hard to find.

Knapp pointed toward a steep bank hidden by tangled roots and an underbrush of willows. The buggy stopped, and Chief Kuemmerling stepped out, followed by Knapp, who hesitated as if trying to find the exact spot. He walked nervously up and down the bank, his face strained.

His "cold stony eyes scanned the river," one reporter noted, as if trying to spot the box containing his wife's body floating in the current. Another reporter saw it differently, saying he had the look of a captive beast, "his eyes filled with a strange, wild, hunted look…for all the world like a maniac or a demon."

The police kept a close, suspicious eye, fearful that the trip was part of a plan to escape. He finally pointed out a spot, saying that was where he had dumped his wife's body in the river.

The scene promised great drama but ended anticlimactically. The officials looked over the spot, murmured thoughtfully among themselves and then wandered back to the police buggies. Before Knapp got back into the carriage, he pulled his overcoat tight around him, took one last look back at the river and shuddered before climbing aboard.

Confession Upon Confession

On the way back to the police station, Knapp told Kuemmerling, "I have something on my mind which I will tell later—but not today."

The chief and the mayor pressed him to continue, but he demurred, saying only, "I will not tell you yet."

After the party arrived back at the police station and Knapp was safely tucked into a cell at the Butler County Jail, Bosch told reporters the story of Knapp's confession. Prosecutor Warren Gard appeared more cautious.

Gard was Hamilton's wonder boy of the bar. His father, Samuel Zearly Gard, was from a prominent Hamilton family and was successful as both an attorney and a newspaper publisher. S.Z. Gard served three terms in two tenures as Butler County prosecutor. He was also the publisher of the *True Telegraph*, the weekly newspaper that would later become the *Hamilton Democrat*. S.Z. Gard's two sons followed in their father's footsteps, one in each shoe, as it were. Warren's brother, Homer, became the city's most successful newspaperman, leading the merger of Hamilton's newspapers into the *Hamilton Journal-News*, which continued to serve Butler County into the twenty-first century.

At age twenty-four, Warren Gard, a future congressman, was the youngest man ever elected to the office of Butler County prosecutor. *Butler County Historical Society.*

Warren Gard took the other path and, in 1894 at the age of twenty-one, graduated from Cincinnati Law School. That same year, he was elected Butler County prosecutor, the youngest man to ever hold that office. He celebrated his thirtieth birthday while prosecuting Knapp and would be elected Common Pleas Court judge in 1907. He would also serve four terms in the U.S. House of Representatives as one of the leading congressmen during the years of the First World War and initiate legislation to temper the temperance movement.

"There will be no evidence that a murder was committed until the corpse is discovered," Gard said, echoing Knapp's earlier statement. "The circumstantial evidence is very strong against him, but we can hardly hope to convict him of doing murder until we are able to show that murder is done."

Meanwhile, Knapp's parents and his sister Sadie Wenzel had employed Cincinnati attorney Charles E. Tenney to represent him. He arrived in Hamilton during the sweat, but the police put him off until after the confession ride. He didn't have his first consultation with the prisoner until Bosch and Gard released the details of his confession to the press.

At 8:00 p.m., another team of interrogators—physicians this time—arrived at the jail to question Knapp. Knapp seemed calm and collected as the doctors took his history. Prosecutor Gard was present but frustrated in his attempts to get the doctors to ask about his crime and former marriages.

"A Typical Degenerate"

The following morning, two of the doctors had scathing things to say about Alfred Andrew Knapp.

"He is a moral pervert and a villain," said Dr. C.N. Huston, "but there is no question as to his sanity and responsibility. His nervous system is normal, the tendon reflexes responded naturally, the pupils of his eyes were normally susceptible to light and shade, there is no insanity in his family, no fits of epilepsy or anything of that sort according to his own statement, and he has three married sisters, one of whom, however, he says has separated from her husband on account of some domestic trouble but all of whom are ordinarily intelligent, but Knapp himself is of a low order of intelligence although he could be educated. He is capable of planning and executing, but to sum him up, he is a moral pervert."

Dr. F.M. Barden said, "He is a typical degenerate…a perfectly sane man and I think is responsible for his actions."

On Wednesday evening, Mamie King was feeling quite ill over the excitement and sorrow over her brother's disgrace as she talked to reporters about her brother's career of mayhem. She expressed her fear that he was guilty of Hannah's murder.

Knapp's fourth wife, Anna Gamble Knapp, a tiny pinch-faced twenty-three-year-old woman of about eighty pounds, vehemently stood by her new husband. She said that he had not been working while living in Indianapolis.

Her foster father had been in the hospital with brain trouble, and she did not like being alone, so they lived there on Owings's pension. She said Knapp was not the monster everyone was making him out to be. "I don't believe a word of it," she said. "If he was that kind of man he had plenty of chances to kill me."

She showed reporters several letters to support her argument that this whole affair was a plot by Mrs. King to separate them. Knapp's sister berated him in the letters for marrying Miss Gamble. The tiny young woman said that she would like to whip Mrs. King for her slander. "You bet I could do it, too," she said. "She's the cause of all my trouble. She didn't like me, and she said mean things about me. I'd go right to Hamilton if they wouldn't lock me up on a charge of murder because I'd stick a knife in that sister the first thing I did.

"I'm going to stand by my husband. If they send him to the penitentiary for murder, I'll go with him."

More Confession

After Knapp's interview with the psychiatrists, Sheriff Peter Bisdorf assigned him to a cell with a local character named Mart Degnan, who was serving thirty days for malicious destruction of property. Knapp had little to say to his cellmate that night, but Degnan reported that the new guy had a restless sleep, continually tossing and turning in his bunk, groaning and gnashing his teeth. Knapp was up early though and ate heartily of the rolls and coffee that were the prisoners' morning meal.

"They're going to do me up all right," Knapp said at breakfast, "and I guess on short order. I think they will get a special grand jury for me."

Crowds of eager sightseers thronged about the jail, hoping to get a glimpse of the notorious Knapp and taxing Sheriff Bisdorf's good nature.

After Knapp's first restless night as the guest of the Butler County sheriff, Mayor Bosch summoned the prisoner, hoping to get more clues as to the whereabouts of Hannah's remains so he could move this case forward. In the room were Kuemmerling, Bisdorf and Lenehan. Knapp seemed to be his same easygoing self, but he remained coy with whatever information he claimed to have, and it soon again became apparent that he would speak more freely if it were again just him and the mayor. At Bosch's nod, the police left him alone with the prisoner.

The First Celebrity Serial Killer in Southwest Ohio

After Alfred Knapp confessed to unsolved crimes in Indianapolis and Cincinnati, the *Cincinnati Post* dug into its archives to create an illustration for its front page. *From the* Cincinnati Post.

At first, Knapp didn't offer up any new information. He again suggested that he knew more and had something else on his mind but just couldn't bring himself to say it. Bosch thought it was about the Motzer girls, but Knapp continued to deny that. So Bosch guided their conversation to Jennie Connors Knapp, another likely topic for a deep, dark secret. Knapp took the bait without a flutter and, in a calm, matter-of-fact voice, mentioned that he murdered her and put her body in the canal.

"And that's not all, Mr. Mayor," he said.

"Great heavens, are there others?" Bosch said, a little unnerved by Knapp's casual air.

"Yes, there are others," admitted Knapp.

"Well, tell me about them," implored the mayor.

"I'd rather write it out. Have you a sheet of paper?"

"Certainly. So you want to make a written confession?"

"Yes, I guess you can call it that," Knapp said, a tone of resignation creeping into his voice. "It's all up with me, anyhow."

As Bosch sought a piece of paper and a pencil, he asked Knapp if the others might join them again, and he consented as he set himself up at the desk.

As the others came in and quietly took seats around the room, Knapp wrote:

> On June 21, 1894, I killed Emma Littleman in a lumber yard [sic] on Gest Street in Cincinnati, and on August 1st, 1891, I killed Mary Eckert on Walnut Street opposite the YMCA building in Cincinnati, and on August 7, 1894, I killed my wife, Jennie Knapp, under the canal bridge of Liberty Street and threw her in the canal in Cincinnati and in July 1895 I killed Ida Gebhard in Indianapolis and on December 22, I killed

Confession Upon Confession

my wife Hannah Knapp at 339 S. Fourth Street in Hamilton and I threw her body into the river out by Lindenwald.
This is the truth. Alfred Knapp.
I made this confession of my own free will and not by the request of any officer or anyone else. Alfred Knapp.

Below it were the signatures of Gus Kuemmerling, chief of police; Peter Bisdorf, Butler County sheriff; and Thomas Lenehan, captain of police. The mayor added his signature: "Sworn to before me this 26th day of February, 1903 in the presence of the above witnesses. C.S. Bosch, Mayor."

The confessions not only solved three nagging unsolved cases in two different cities that police never dreamed were related but also put Knapp on par with the likes of Jack the Ripper, whose unsolved murders have been intriguing imaginations for well over a century now. In 1903, those murders were still relatively fresh—only fifteen years past, more recent than Knapp's own early crimes.

After reading the confession, the police wanted to know why he didn't include the attempted abduction of the Motzer girls in his confession. Knapp stuck by his earlier statement: he didn't have anything to do with it. Some of the men present felt that he was just afraid of a lynching.

Even on the eve of Roth's trial, Knapp was enigmatic about the case. When Officer Hetterick told him that Roth's trial started, Knapp said, "Well, he is innocent."

"How do you know that, Knapp?" Hetterick asked.

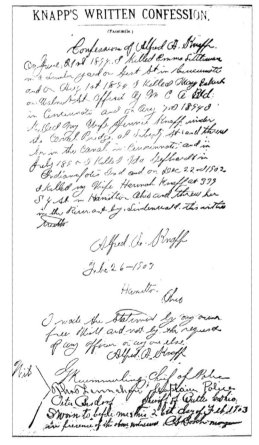

Newspapers took pictures of Knapp's handwritten confession. *From the* Cincinnati Enquirer.

Knapp just smiled at him.

"If you know that poor fellow is innocent, why don't you just come out and say so?"

"I didn't do it," Knapp said. "I've got enough on me now."

The news echoed across two states and the nation, solving some of the biggest unsolved mysteries on the books in both Cincinnati and Indianapolis. Until Knapp's confession, there was never any thought given to a link between the four deaths.

Meeting the Press

On the Thursday afternoon after Alfred Knapp's stunning confession to a total of five murders of women and young girls, Sheriff Bisdorf and Mayor Bosch allowed a group of reporters to speak with the prisoner through the bars of his cell in the Butler County Jail.

There were so many reporters present that they relocated to an adjoining room, where the parties made themselves more comfortable. According to some reports, Sheriff Bisdorf even gave Knapp a cigar while they talked. The prisoner was accommodating and matter-of-fact and did not hesitate in any of his answers. He was "entirely quiescent," the *Sun* reported, and apparently relishing having so many people hanging on his every word as he calmly regaled them with his exploits. "He certainly presented a picture," the *Cincinnati Enquirer* wrote, "of brute indifference, for while mild-mannered and talkative, he does not in the least realize the enormity of his offending and the doom that awaits him."

When he wasn't playing it cool and calm, Knapp would become animated and dramatic at points in his narrative. When talking about strangling his victims, he fingers would draw up with tension like talons of a bird of prey. His hands had unusual strength in them, which he credited to his work as a trapeze artist in the Forepaugh show. His face drew itself up into hard lines, and his eyes drooped toward his nose, his nostrils dilated and his breathing hard.

Knapp revealed that not only did Hannah help him kill Mary Eckhart, but she also had committed a murder on her own, of her own child:

> *In May, 1894, she smothered her own baby to death and said it was an accident. The baby was only a few months old and she had to get rid of it. One night she ran up to the city hospital in Cincinnati carrying the baby in*

> her arms. It was still breathing but almost dead and it died in a short time. She told the hospital that she had found its head buried under the covers of the bed when she woke up and she did not know how it occurred. Her word was never questioned and she was never even suspected of the murder. We were talking one day about the Eckert murder, and Hannah told me all about it herself. She said she fixed the body in bed and then rolled over on it. She ran to the hospital only as a bluff.

As he talked, he leaned back in his chair and puffed calmly on the cigar. He scratched his head as if to draw the memories forward. "The fiend made the statement as coolly as if he would talk about a summer game of athletics," the *Indianapolis News* reported, with the *Daily Republican* concurring: "The monstrous and perverted wretch talks of his crimes as but commonplace occurrences."

"I was walking along the street near home one day, and this little girl came up to me," he said as if recalling an amusing anecdote. "I didn't know where she lived at the time and when she followed me I just let her come along. I don't remember where I was going at the time. It began to rain, and we stopped in an open barn in the rear of River Avenue, I should judge about eight blocks from my home. I killed her when we got inside."

While the press—and presumably the public—were eating up every little tidbit about Alfred Knapp in the days that followed, reporting lengthy accounts of his crimes and his interviews, it remained to be seen how much of it was fact and how much the product of Knapp's imagination. A reporter from the *Cincinnati Evening Post* tried to trip him up on the dates he gave for some of the previous crimes, saying they didn't correspond to the official record, but Knapp held fast and was correct. So many reporters descended on Hamilton that the Western Union office brought in two more operators to handle the volume of transmissions headed to newspapers around the country.

The Strangler's Wife

On the Friday morning following Alfred Knapp's arrest, an *Indianapolis News* reporter approached Anna May Gamble Knapp and asked her if she had ever awakened in the middle of the night with her husband's hands around her throat.

She clung to the partially open door of the basement apartment with one hand, clutching a loose-fitting, dirty black wrapper at the throat. Her thick

black hair was scraggly and matted. She was described as "hatchet faced" with close-set, penetrating eyes. Her growth seemed stunted both physically and mentally, and the reporter said she could be taken to be anywhere between fifteen and fifty, though she was supposed to be twenty-three.

The squalid basement room, formerly an old paint shop, was sparsely furnished and divided in two by a filthy old piece of well-worn carpet. Everything looked dirty.

George Owings, her foster father and a Civil War veteran, had just been released from the hospital, and a well-dressed old army comrade of his was visiting. The old man sat dejectedly in a chair while Annie ranted at the reporter, her shrill voice rising louder and louder until it could have been heard in the street, the report said.

"No, he didn't!" she screamed. "And it is none of your business if he did. It's nobody's business if I wanted to live with that man. I don't see what business it is of anybody's."

"But Mrs. Knapp," the reporter said, "this man is a confessed murderer and it would have been only a question of time until he would have murdered you."

"I wouldn't have cared if he had murdered me! I wish he had murdered me. I'm going to see him if I have to walk all the way. And I am going to Cincinnati to see his folks. You wait until I see that sister of his, Mamie, and I'll murder her," Annie yelled.

"What's the matter with Mamie?"

"She's the one that caused all this."

"But Mamie surely didn't murder any of these women."

"No, but she told on my husband. If it hadn't been for her, we would be living together."

"Would you want to live with a man you know is the greatest fiend in the world?"

"Yes, I would. I don't care what he is or how many people he murdered. He didn't murder me, and that's all I care for."

"You're sure Knapp didn't choke you at any time?"

"No, he didn't!" she screamed and burst into tears, throwing herself on one of the dirty beds in the dismal basement apartment.

"Mrs. Knapp, if all the expenses are paid and you get two dollars to boot, will you have a picture taken?"

"Not on your life," she wailed, then got up from the bed and began to dry her tears. "I want you to understand that I ain't goin' to talk any more, to you nor the police."

Confession Upon Confession

At this lull in his daughter's tirade against the world, the old man had a chance to tell what he knew of Knapp.

"I knew nothing about him," Owings said, "until he came to visit his folks in this block. His parents were nice people and I thought him a nice man. He went to church several times and I liked him all the more. When he wanted to marry the girl, I thought it was a good match and consented." [See notes section at the end of the book for more information.]

"So what did you think of Knapp?" the reporter asked the sick old man.

Before he could answer, Annie screamed, "Nobody cares what you think, Daddy!" It was enough to squash what little spirit the old man had, and he sank into silence.

"George, you can come and stay with me," the well-dressed man said, "if she insists on going to Hamilton or having anything to do with this murderer."

The press was not particularly kind to Alfred Knapp's fourth wife, Anna May Gamble. *From the* Hamilton Evening Sun.

Annie shared a letter from Alfred with the reporter, one she'd received the previous day and that he had apparently written sometime during his first day in Hamilton.

My Dear Little Wife:
I will drop you a few lines to let you know how I am getting along. It looks very dark to me, and so we will have to expect the worst. I don't know what they will do with me, but I expect it will be life in prison in Columbus, O., as they are on the track of Hannah. They have not found her body, but may find her by the time you get this letter. I won't write much this time, but as soon as you answer this I will write more. But, oh, my darling sweetheart, it is hard to be parted from you. But be a good girl for Allie and take good care of yourself. You know what I mean don't you? Now write me a nice long letter. Don't forget your kid, and he will never forget his little sweetheart as long as he lives. I will tell you all in my next letter.

> Write just as soon as you get this. How is Daddy? With love and kisses,
> I will close,
> Your Loving Husband Until Death.
> P.S.—Get our marriage certificate from the police. Write at once. Allie to Annie. Address Alfred A. Knapp, Butler County Jail, Hamilton, O.

Annie told the reporter that they didn't have a courtship, that he never wooed her and that they were not engaged. "He wanted me and I wanted him and we just went and got married," she said.

The reporter told her that the only chance of Knapp not dying in the electric chair would be a plea of insanity. She seemed okay with that, saying that Knapp had often acted "queer."

"If they give him another chance," she said, brightening up, "I will make a good man of him. Why, the worst they can bring against him is bigamy, and that ain't much."

Kicked in the Head

A search party from Hamilton went to Lawrenceburg, Indiana, where the Great Miami River meets the Ohio River. Reporters there not only checked on the progress of the search but also found Jennie Connors's mother, Mrs. Paul Lemuel, who said she didn't even know her daughter was dead until Knapp confessed to her murder. Knapp was well known there. His theft of a pool table from a local saloonkeeper earned him his second stint at Jeffersonville Prison. One man who knew him there said he was a born thief and would steal anything he could get his hands on.

On Friday morning, Knapp's sister Sadie Wenzel delivered a letter to the local newspapers:

> I believe that my brother Alfred is insane and if he has committed the crimes to which he has confessed, he is not responsible for his actions. He loses his head completely in the presence of a woman, and I would have had him adjudged insane long ago but I was afraid it would kill my father and mother. When my mother heard of Alfred's trouble she said: "If Cyrus had made this confession, I would go right now and kill myself, but Ally is not responsible for what he has done." Cyrus is my younger brother who lives at home with us. Mrs. Sadie Wenzel.

Confession Upon Confession

At police headquarters, she told the story of how her brother had not been in his right mind since he was five years old and kicked in the head by a colt when the family was living in Twenty Mile Prairie, Illinois. He was unconscious for a day and a half, for three months "not in his right mind" and continued to act strangely for two more years. When he was ten years old, he fell from a tree in Genesee, Illinois, and sustained a concussion that left a still noticeable dent on the back of his head.

These two accidents affected her brother's mind, she said. She also said the change of the moon caused him to act in a strange manner ever since and that he had suffered for years with intense pains in his head.

She also revealed that she and her husband, then in Chicago, were separated because she caught him with Hannah Goddard in a wineroom at Ninth and Elm Streets.

THE STRANGLER'S TALES

On Friday evening, the confessed strangler and serial killer Alfred Knapp sat down for a lengthy interview with the *Cincinnati Enquirer*, offering up in salacious details of how he committed his crimes. The paper devoted its entire Saturday front page to the story, with a three-column likeness of Knapp above the fold.

"With a frankness only akin to his wantonness, Knapp narrated a story such as has seldom, if ever, been equaled in fiction," the introduction read, under a curious headline evoking the names of Caligula and Nero. "Calmly, and with a deliberation such as only one of his temperament can possess, he told, with reckless disregard for the consequences, of the bloodstains on his hands…a story which at best is a blot in the blackest page of individual criminology."

The reporter said that Knapp seemed a bit languid and tired when he first entered the sheriff's parlor to conduct the interview, but "a few words recalling some of his bloody work sufficed to arouse him from his lethargy, and he was soon discoursing glibly on subjects well calculated to make the average mortal stand aghast."

Knapp said that he committed his first crime when he was seventeen years old and got caught at it. He had gotten a job on a steamboat and stole a suit of clothes from a shipmate. He had the audacity to put the suit on when he embarked at Madison, Indiana, and so he was arrested when the boat got to Cincinnati. He spent some time in the Cincinnati Workhouse for his infraction.

He had been married to his first wife, Emma Stubbs, for just three months before he earned a sentence in Jeffersonville for the attempted rape of a schoolteacher. He maintained his innocence for that crime, saying he pleaded guilty on the advice of his attorney.

"Then why did you plead guilty?" the reporter asked.

"Well, my record was against me, and I was told that I could get off with four years instead of fourteen if I pleaded guilty, so I did it," he said. "You see, I had a bad record and stood no chance of being acquitted."

When the reporter asked him about his unnatural passion for strangling women, the villain said, "Well, I can't describe it. I seem to have taken a dislike to womankind, and yet I like to have them around me. It seems that when I see a pretty woman something behind me pushes, while something in front pulls me, and I am not satisfied until I have my fingers clutching their throat."

"A Good Chunk of a Girl"

Alfred Knapp told the *Enquirer* that he killed Emma Littleman when Popcorn George's Circus brought them to Cincinnati:

> *The circus was exhibiting on Gest Street and I went down there to have the baggage wagon call for my trunk and that of my wife. It was on Saturday, and a hot day in June. Jennie and I were to leave with the circus that night. Coming back from the show late I passed the lumber yard* [sic] *and went inside to sit down in the shade of a pile of lumber. While I was there, the girl came in with a basket on her arm. She was a good chunk of a girl, 12 or 14 years old, I should say, and well developed. I spoke to her and she answered me. She said she was gathering up some kindling wood. I broke up some laths for her and then she sat down by my side, and I took liberties with her. She did not protest against what I was doing. She consented to my advances, but then she began to scream.*
>
> *There was a man working on a pile of lumber 20 feet away from where we were and I was afraid the girl's screams would attract his attention. I told her to keep still, but she would not. After a few moments, I realized that I had gone too far, and I was afraid she would recover and tell what happened, so I hit her on the head with a triangular piece of lumber which lay near where we were. I stuffed her body under the lumber pile and went*

home. That night, Jennie and I left with Hall's circus, and the next day I read in the Enquirer *at Aurora of the finding of the body.*

"Did you sleep that night?" the reporter asked.
"Oh, yes, I slept, but whenever I thought of what I had done and remembered how the body looked, it made me sick. I did not get over this feeling for several weeks after I had killed her."
"Did you tell your wife what you had done?"
"No. I never told anyone about it," Knapp admitted.
"How long did you remain with the circus?"
"Several weeks. We left the show near East St. Louis because Jennie could not stand the work. Then we came back to Cincinnati."
"Did your conscience trouble you for what you had done?" the reporter questioned.
"Yes, I was sorry I did it, but I was afraid of being arrested. That's why I killed her."

"There Would Be Murder"

Knapp said that he became acquainted with Mary Eckert when he answered an advertisement for a correspondent in Dayton. He wrote to her asking her to meet him in Cincinnati, and she did so.

I took her to a cheap hotel, and we registered as husband and wife. I could not remain with her at night because Jennie and I were living with my sister, Mrs. King, at 12th and Elm streets. I told her that I was married but I did not tell her about Emma Littleman. Suddenly, Mary Eckert disappeared and I did not know where she went. One morning, several weeks later, I was walking down Walnut Street and I saw her standing at the window at the house on Walnut Street opposite the YMCA. I went over and spoke to her. I learned that she had been to Dayton to see her husband. After I knew she was back in Cincinnati, I called on her every day. She wanted to meet my wife, and I took Jennie to the place and introduced her to Mary. Later on I took Hannah Goddard to Mary's house and introduced her. The morning of the murder, I called at Mrs. King's house for Hannah and walked downtown with her. Hannah was then employed as a waitress in Rockwell's restaurant on Walnut Street, almost opposite the Columbia Theatre.

The First Celebrity Serial Killer in Southwest Ohio

> *On the way down, I bought an* Enquirer *for Mary as she was looking for a place to work. When Hannah and I reached Mary's house, I asked Hannah to come inside with me. It was about six or a little after six o'clock in the morning. The front door was open when Hannah and I went in. Mary was up and dressed and she let us in her room. Shortly after Hannah and I arrived, Mary went to the butcher's shop for meat for breakfast. When she was gone, Hannah and I lay down on her bed. We were still there when Mary returned. When she did, she seemed to find fault with the liberty Hannah and I had taken, and she said she intended to tell Jennie what we had done. I knew if she told Jennie there would be murder one way or the other as Jennie had a bad temper and often quarreled with me about women. When Mary Eckert went out a second time for rolls for her breakfast, Hannah and I discussed what we had better do.*
>
> *Hannah knew as well as I did that if Mary told Jennie she would kill one or both of us unless we killed her, so Hannah suggested we kill Mary to keep her from telling. I consented, and when Mary returned from the baker's I grabbed her by the throat and choked her while Hannah held her hands. When she stopped struggling I let her down on the floor and tied the towel around her neck. Then Hannah and I went out separately.*

"Did Hannah go to work that day?" the reporter asked.

"Oh, yes."

"What did you do?"

"I strolled around town and then went home," Knapp replied.

"How did your wife come to suspect you of the murder?"

"She read it in the *Enquirer* the next morning and as soon as she read it, she accused me of doing it and threatened to tell the police. I denied it, but she seemed to know that I did it and she said she would never have anything more to do with me."

"Then you decided to kill her?"

"Not right away. She wanted to die and agreed to let me choke her, and I did so."

"We Wrangled and Wrangled"

After Jennie and Alfred quit the circus, he told the *Enquirer*, they drifted to Cincinnati, and that was when their troubles started. Jennie was intensely

jealous, and when she came to know Mary Eckert, she constantly charged her husband—rightfully—with undue intimacy with the woman. When Mary Eckert was found dead on July 25, Jennie charged her husband with the crime, though he says she had no reason for doing so (except, according to his story, he did). She also regarded Hannah Goddard as a thorn in her side, and since Knapp had been intimate with both of them, and feeling that his wife knew about it, he began to fear her.

He said that she made life very "lively" for him. On numerous occasions he wrested knives and revolvers from her. The night prior to her death, as they were walking along Liberty Street, she suddenly "sprung on him like a tiger," and in their scuffle, she bit him on the right shoulder.

The night following, Knapp had some business downtown at the *Enquirer* office, and they set out together, but quarreled incessantly along the way. Knapp said that Jennie wanted him to commit suicide with her. When they reached the Twelfth Street canal bridge, she said, "Here's as good a place as any."

"I might have jumped off the suspension bridge," Knapp told the *Enquirer*, "but I knew there wasn't enough water in the canal to drown either one of us, so I declined. We then walked along the canal bank until we reached Liberty Street. There we wrangled and wrangled. But she was stuck on committing suicide and I was afraid of her because I thought she knew that I had killed Mary Eckert—and also because I feared she might kill me.

"Well, she kept on talking suicide until I just thought I'd help her, so I got her by the throat and choked her pretty hard. Then I let go to see if she'd changed her mind, but as she didn't even whimper, I again choked her until I thought she was dead and tossed her in the canal.

"I know she wasn't dead when she hit the water for she sort of struggled for a minute, but she soon went down and the water did what I overlooked," he said.

Knapp said that he went to his lodgings at Bauer and Central Avenues and the next morning read of the supposed suicide of a woman in the canal.

"She Seemed to Be Lost"

Alfred Knapp told the reporter that the murder of Ida Gebhard during the summer following the Eckert and Littleman murders was purely a matter of opportunity. After having been missing for several days, the girl's body had

been found in a toolbox in a stable. It was badly mutilated, and a bloody hatchet with tufts of her hair was also found in the stable. Knapp was between prison terms and staying with his parents in Indianapolis.

> *I have tried to explain to myself why I killed that child, but I cannot do it. I certainly had no reason to kill her. I was down on River Avenue, I think it was, to mow a lawn, and met the child on the sidewalk. She seemed to be lost, though I learned afterward that when I met her she was standing a few feet from her own gate.*
>
> *I had no intentions of harming her and she did not ask to go with me. She followed me and asked me for candy, but I did not have any and told her so. When I reached the stable, she followed me in. I don't know what made me do it, but I could not resist the temptation to choke her. I grabbed her from behind and choked her until she was dead. I did not assault [rape] her nor did I hit her with a hatchet. I killed her by choking her. If her skull was split open with a hatchet I did not do it, at least I have no recollection of having done it.*
>
> *After she was dead, I put her body on a tool box that stood near. There was another box and a piece of oilcloth on top of the toolbox. I took off the upper box and oilcloth, put the child's body in the toolbox, then put back the oilcloth and the box on top of it. Every time I thought of how that body looked it made me sick, just like when I thought of Emma Littleman's body. After stowing the body in the tool box I left the station and went to my parents' home. I am telling the truth when I tell you that I did not assault the child and I did not mean to kill her. I don't know why I did it, but I did.*

"A Pure, Honorable Girl"

The *Enquirer* interview also related once more the details of his murder of Hannah Goddard. It also revealed some new information, including Knapp's admission that Hannah had a baby in May 1894 at the Cincinnati Hospital before they were married and that he knew she had been unfaithful while he was in the Michigan City prison. He also said that he feared Hannah's Uncle Charley Goddard: "He is not a man to be fooled with."

The reporter told Knapp that Ed King predicted on Wednesday that Knapp would confess to the murders of Ida Gebhard, Mary Eckert and Jennie Connors.

"I don't see how he knew that," Knapp said. "I never told anybody until I told Mayor Bosch."

Dr. H.H. Hoppe of Cincinnati, a renowned "alienist," an expert on mental and nervous disorders, gave Knapp a physical examination and sat in on the interview with the *Enquirer* reporter. His report said that he believed Knapp committed the crimes he confessed to but that he didn't believe Knapp's contention that he was in an epileptic or other transcendent state of mind when he killed Ida Gebhard. He said that Knapp was "a well-developed man, apparently free from constitutional ailments of a physical nature, and with none of the usual facial characteristics of the moral pervert of which he is the most pronounced in nature I have ever seen…He is not a sexual pervert, however." His physical examination indicated some abnormalities, perhaps lesions of the brain, but not so much as to "render him irresponsible for his actions."

Alfred Knapp confessed to the murder of Ida Gebhart in Indianapolis, a crime committed just before he was caught trying to assault Bessie Draper. *From the* Indianapolis News.

Because Knapp so vividly discussed his life story and passion for crime, his entire family found its dirty laundry aired in the pages of the newspapers. This included a rift between Sadie Wenzel, who felt she needed to protect her parents and her troubled brother, and Edward and Mamie King, who were now convinced that Alfred should suffer the consequences of his actions. They stood by the memory of Hannah.

"Hannah Goddard did not know my brother until fully two weeks after the Eckert murder," Mamie King told the *Enquirer*. "She, therefore, did not

aid him in that deed. It is absolutely false that Hannah caused the separation of my sister, Mrs. Wenzel, and her husband."

Mamie King told quite a different version of the "caught in a wineroom" story:

> Hannah and I had been on a visit to Indianapolis, and my husband and brother-in-law Mr. [Charles] Wenzel, who had been together during the Sunday on which we returned, called for us at the CH&D depot. The day was hot and we were dry, and I suggested that I would like to have a little lunch. We walked up as far as Ninth and Elm streets, where we stopped for refreshments. Mr. Wenzel told his wife about it the next day, and that set her in a temper. She accused Hannah of misleading her husband when the girl was really innocent of any evil intention. Why, my sister and her husband have been separated a dozen times, and at present he is in Chicago and she is living with her brother on Freeman Avenue.
>
> Hannah Goddard was a pure, honorable girl, but my folks never liked her and would not speak to her. The letter my sister received from Alfred, showing his insanity, contained the phrase in which he said my father was not his father, that his father was Adam Forepaugh. He also claimed to be a circus acrobat, which he never was.

The Kings were convinced that Alfred was insane, and they described him as we might describe a werewolf or vampire today. Because of his injuries, he always had "a nervous disposition," and they said that he would have spells with the changes of the moon. His eyeballs would assume a different color and his entire being would undergo a metamorphosis. The heat also affected him adversely, they said. But when not in his moods, he was an affable and social fellow, which they believed accounted for his attraction to women, even though he was not a handsome man.

"Every Family Has Its Black Sheep"

Sadie Wenzel also used the press to speak out against her sister and brother-in-law during a brief interview at the candy store, saying, "I will stick to every member of my family but one, as long as any blood remains in my veins or as long as I am able to hold up." She would not say specifically which member she excluded and would not allow the press to interview her

parents. Sadie said she was not ready to talk, though she did a fair amount of talking:

> *My duty is to my father and mother. I will take care of them as long as I am able. I rented this store and started my father in business in order that he might have something to occupy his time. I went to Indianapolis where he lived and brought him back here. He was working hard there when he should have been in bed* [with the grip, or influenza]. *When I went to Indianapolis he was driving a team and shoveling ashes. He was feeble and I got on the wagon and drove for him and shoveled the ashes in the wagon myself. I persuaded him to sell the team and come to this city where I could be with him and mother. When they came, I rented this store. My father*

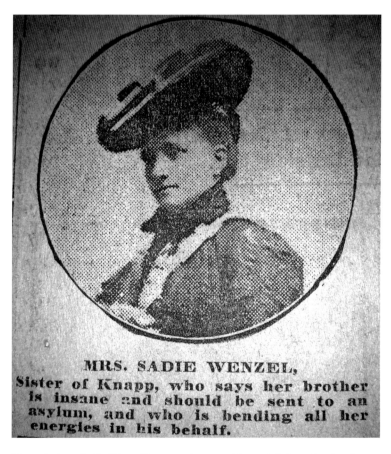

Knapp's sister Sadie Wenzel became almost as big a celebrity as her brother. *From the* Cincinnati Commercial Tribune.

has an independent disposition. I knew that he wouldn't be content to stay around and do nothing while someone else supported him. It was for this reason that I put him in business. When I brought him here I had consulted a specialist, who is now treating him.

If I were to turn against my father and mother, they would have nowhere to go. There is no other one to look after them. My love for my people is deep and it takes a lot to make me turn against any one of them. But one of them has done that which I cannot stand for, and I will never have anything more to do with that one. The mother has been turned from the door of that one.

The papers have had stories about my brother, but I will have a bigger story that will come out soon. I will present facts when I do talk and the world will be forced to believe that what I say is the truth, but before I say anything I must have time to think the matter over. When I make my statement, it will clear up several things.

Every family has its black sheep, and Alfred, I suppose, is the black sheep of our family. I have lots of friends in this city and the friendship of some of these I value very highly, but it seems that every member of a family is held responsible for the sins of one. Some of those I know seem to hold this view, but I can't desert my family. My trip to Hamilton was a personal matter, and whether or not I shall go there again is a matter I do not care to discuss.

False Leads

Saturday was "washing day" at the Butler County Jail, when every prisoner had to take a bath, don clean underwear if he had it and, if he desired, get a haircut and a shave. Knapp didn't have any clean clothes, but Jailer Ben Clark donated underwear and a suit. William Gaines, a black man serving a sixty-day sentence for wife beating, removed two weeks' of growth from Knapp's face. The fresh look had a surprising effect on Knapp's demeanor, playing to his vanity. He allowed Gaines to give him a haircut as well.

With Hannah gone for over two months and no corpse in sight, police were following up on even the thinnest of leads, thinking that maybe Knapp had been lying about putting the shoe box with the body in it into the Great Miami River.

Charley Goddard had told them that shortly after Hannah's disappearance, he learned that Knapp had sent a box and a barrel to the CH&D freight house to be shipped to Indianapolis. He found Knapp and made him go back there

and unpack the boxes because he suspected Knapp had some of his own belongings in there. Goddard threatened to have Knapp arrested for larceny if he did not return the items, which included an alarm clock. He and Knapp went to the freight yard, where Knapp opened up the barrel and returned the goods, but Goddard did not see what was in the box.

That story got police to thinking: What if Hannah's body was in that box? That mystery was solved quickly enough when the freight yard foreman said the box wasn't big enough to hold Hannah's body.

The most puzzling thing about the ordeal so far wasn't really where Knapp might have stowed the body of Hannah, which would be resolved soon enough. Rather, it was the seemingly random nature of Knapp's crimes. Although he casually expressed a preference for strangling women from behind, the record didn't really bear that out. If his confessions were to be believed, the evidence showed that he struck his victims, both with fists and with cudgels, and he stabbed some of them. Some of them he stalked, while others suffered under his hand just by being in the wrong place at the wrong time.

An Old Soldier's Rage

The Civil War veteran George Owings got word on Saturday that he was being evicted from the dingy little basement apartment that he shared with his foster daughter, Anna May Gamble Knapp.

"I am not responsible for this," he shouted at a reporter, waving the eviction notice in his trembling hands. "My rent is paid to date and I can pay another month's rent on Monday or Tuesday when my pension check comes. My daughter is awful sick." Then lowering his voice to a confidential tone, he said, "She wants her husband."

From the other side of the dirty rug that turned the dank cellar into a two-room apartment, the reporter heard a plaintive wail, followed by stronger groans intermingled with sobs. Finally, a voice fluttered out, "Who's that with you, Daddy?"

"One of them newspaper fellers."

"Bring him in here," she demanded.

The "feller" obeyed, asking her, "Have you heard from your husband today?"

"No, I haven't," she said. "I wish I was dead. I'm goin' to Hamilton or bust, you can bet on that." She started sobbing and wailing again, and the old soldier entered the curtained portion of the room.

"You know that the newspaper fellers are responsible for me being put out of this place," he railed. "If it hadn't been for you fellers the landlord wouldn't have known nothing about Knapp."

He tramped back out into the other portion of the room and spit in an old cooking stove, which wasn't doing much good to warm the dank place. "The temperature in the room was lower than a butcher's ice box [sic]," the reporter noted, "and the dampness was so great as to almost create a fog."

When the old soldier's rage subsided, he remarked that he was "not stuck on the room anyhow" and that he could get a better one for three dollars. When the reporter returned later in the day, no one was at home, and he wondered if they had moved.

He Had Two Accidents

On Saturday evening, Sadie Wenzel finally allowed an *Enquirer* reporter to conduct a brief interview with her mother, which was printed in the Sunday paper. Susannah Knapp, sixty-three, was choked with emotion, saying that she'd never had such trouble in her life.

"It is terrible to be disgraced by one of the children after having reared a family of boys and girls as I have done," she said. "In all my life I never had my name in the papers but once before, and that was when I was married.

"Allie is insane," she said. "No man in his right mind would talk as he does. He had two accidents when only six years old, and he has never been right since…I don't believe all these things he says. They can't be true. If he were in his right mind, he would never confess to such crimes."

Sadie also used the opportunity to add fuel to the wineroom fire. She confirmed the first part of the story about Mr. King and Mr. Wenzel meeting Mary and Hannah at the station.

"They drank several glasses of beer" in the wineroom, Sadie said. "While in the room, Hannah sat in Mr. Wenzel's lap. The next morning, Mrs. King told me about it, and when I mentioned the matter to my husband, he replied that it was none of my business and we quarreled."

"My husband had been going to the King home to see Hannah and had given her money," she said. "Mrs. King told her to 'pull his leg,' as he did not give me any money anyway."

She also denied receiving the crazed letter from Alfred saying that Hannah was "dead and gone to hell" and that he was really the son of the circus owner Adam Forepaugh.

"Mr. King, with the sanction of Mrs. King, ordered my father and mother never to set foot in their house again," she said. "It was two years ago when father and mother lived in Indianapolis. Mrs. King wrote a letter to her sister-in-law Ida, Cyrus Knapp's wife, and enclosed a short note to father. Father sent word to write him a long letter or she need not write again. In a few days, he received a very bitter letter from Mr. King."

Sadie continued, "It is a fact that Cyrus [Jr.] eloped from Indianapolis with a girl and married her, and that the marriage afterward was annulled. Mrs. King planned the marriage. She had the girl come here to visit her, then sent for Cyrus. She took them across the river to Newport, Kentucky, where they were married and then took them back to her house. When she grew tired of them, she kicked them out and they returned to Indianapolis. The girl's mother and I had the marriage annulled."

Sadie did echo her estranged sister's opinion of Knapp's sanity: "When Judge McRea at Indianapolis sentenced Allie to the Michigan City Penitentiary, he stated that the prisoner should be sent to an insane asylum and not to the penitentiary. I wanted to sue out a lunacy writ at that time, but on account of Mother and Father I did not do so."

A Victim's Father

On Sunday, Alfred Knapp received a number of visitors—family, law enforcement and press—but the most dramatic was the visit of Herman Littleman of Cincinnati.

In his first expression of remorse, Knapp said, "I am just as sorry as can be that little Emma is dead. She had eyes and hair like yours, but a little lighter. Yes, the girl favored you greatly."

Littleman turned to the sheriff. He was tense but calm and spoke softly. "I have never seen this man," Littleman said. "I do not care to look at him anymore."

As Littleman turned away, the sheriff shot a glance at Knapp and caught him wiping away a tear, the first sign of any genuine emotion or remorse the prisoner had shown since he was brought to Hamilton.

An *Evening Democrat* reporter called on Knapp to clarify some points about his narrative on the murder of Mary Eckert, specifically asking him about the knife wound to the victim's neck.

"Well, you see, I seldom carry a knife. If she was stabbed in the throat, maybe I did it, but I can't recall using a knife on her. I believe I did have a knife at that time, and in the first excitement I might have used it."

"You say that Hannah Goddard was with you when the killings occurred?" the reporter asked.

"Yes, she was and helped."

"You and Mary were good friends, weren't you?

"Well, I guess," Knapp said with a smile.

"Was Hannah jealous of Mary?"

"I don't know. Maybe."

"You said that it was during Mary's absence that you and Hannah decided to kill her. Why was that?"

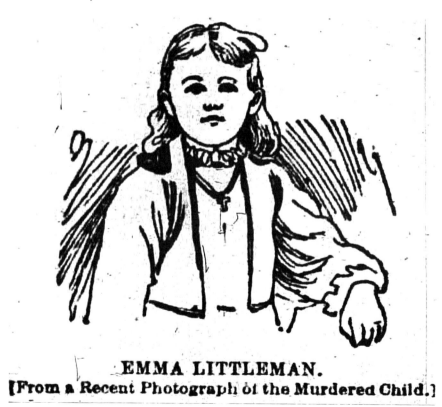

EMMA LITTLEMAN.
[From a Recent Photograph of the Murdered Child.]

Alfred Knapp confessed to the unsolved Cincinnati murder of Emma Littleman in a Gest Street lumberyard. *From the* Cincinnati Enquirer.

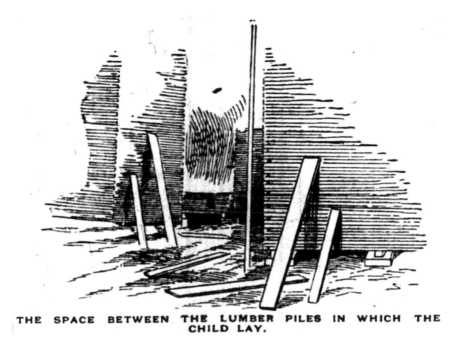

THE SPACE BETWEEN THE LUMBER PILES IN WHICH THE CHILD LAY.

The *Cincinnati Enquirer* published an artist's rendering of the lumberyard where Emma Littleman's body was found. *From the* Cincinnati Enquirer.

"She raised a rumpus with both of us on coming in after having been out to the grocery. Hannah didn't like her very much, and I was sore because of the row she kicked up, so we decided to fix her when she came back, and we did. I'm not sure about the knife, but if she was stabbed in the neck, I did it."

Sheriff Bisdorf started to show some impatience with all the press and the attention being given to the prisoner. It reached a head on Sunday evening when a gaggle of newspapermen were taking pictures of Knapp in the jail, trying different poses and taking close-up shots of his hands. Someone suggested they get pictures of him with his hands around the neck of a female model. Somehow, they managed to find a woman gullible enough to participate, but Bisdorf got wind of the scheme and put his foot down. Although he put a moratorium on press access to the jail, there were plenty of other opportunities for the press to exploit this scandal, and they did. Because the scandal spanned two states and three cities—each with at least three or four daily newspapers—Hamilton was brimming with visiting press and excitement.

The First Celebrity Serial Killer in Southwest Ohio

Mayor's Court

Alfred Knapp made his first court appearance on Monday, March 2, five days after his arrest. At 11:00 a.m., the prisoner was quietly escorted from the jail by Police Chief Kuemmerling and Sheriff Bisdorf into a buggy that took them to the mayor's courtroom at city hall. The matter had been kept secret from the newspapers—and from Knapp's lawyer, who was not present. But somehow Sadie Wenzel had gotten word of it and was on her way from Cincinnati.

Knapp seemed cool and collected, not half as excited as the others in the room. He was well groomed for the occasion, wearing a brown coat and vest, dark jeans and a coarse pair of boots. He had on a clean white stiff-bosomed shirt and a turndown collar with a neat red-and-black bow tie. He was cleanly shaved except for a short, neatly trimmed mustache. His hair was not parted but combed down over the forehead and brushed over from the left side to give the appearance of a part. On the little finger of his left hand, he wore a heavy plain gold band. He smiled and talked to everyone who spoke to him in a very affable and pleasant demeanor. There was a delay of about ten minutes while the court waited for Sadie Wenzel, Knapp's sister, to arrive.

The crowd wasn't large, perhaps twenty people, but the stunning and sophisticated woman drew all eyes her way when her handsome figure entered the waiting courtroom. Some reporters noted that she and Knapp looked a lot alike, but she was better looking. She had been an artist's model for some time and had posed for some World's Fair work in Chicago. She was not living with her husband but rented a small candy store at 935 Freeman Avenue in Cincinnati that she gave to her parents. They all lived together, along with the youngest son, Cyrus Jr. A slender, refined lady with dark black hair, Sadie resembled her brother in facial appearance but seemed vastly superior intellectually. She had an excellent command of language and the ease and grace of one accustomed to the drawing room, in spite of her humble upbringing. For her first court appearance with her brother, she wore a black skirt and a fur-trimmed dark red bodice and cape of the same material. Her hat was brown cloth with a large black plume curving almost around it. Her tasteful accessories included a gold watch and a long chain. She sat at Knapp's left when she arrived and gave every appearance of being his guardian mother hen. She kept a piercing set of black eyes on the prisoner.

When court was called to order, Mayor Bosch told Knapp to stand to hear the charge against him. Knapp rose and stood awkwardly with his hands

thrust into his trouser pockets while Clerk Steven A. Weber read the affidavit charging Knapp with the murder of Hannah Goddard Knapp.

When the mayor told him he could plead guilty or not guilty as he wished, Sadie flashed a glare at her brother that "fairly sparked fire," one reporter said.

The prisoner hesitated a moment and then said firmly, "Not guilty."

The reply caused the courtroom to stir. Bosch asked Knapp if he wanted to claim his right to a preliminary hearing, and he replied, "I guess I do."

"Well, you will have to arrange that between your attorney and the prosecutor," the mayor said.

Knapp hesitated again, but before he could speak Sadie was on her feet.

"To whom am I speaking?" she politely asked.

"The mayor," said Prosecutor Gard.

"Can I speak?" she asked. Bosch motioned for her to continue. "We haven't decided definitely on the attorney as yet but will as quickly as possible, and then I'll let you know."

When court was recessed, Mrs. Wenzel called Mayor Bosch aside and asked for a private audience, which he granted. They spent about twenty minutes together alone in his office. When Sadie emerged, reporters surrounded her asking for an interview. She replied that she had nothing to say to any reporter and there was no use trying to get her to talk, and this time she actually said nothing more.

Bosch, however, was not so reserved. He said that Sadie believed that her brother was not guilty of the crimes that he had confessed to; he was not accountable for all he had said or done because if he had said and done all of those things, then he was insane at the time. But if he were guilty and in his right mind, then he should be punished.

In other words, all she had to offer was nervous chatter.

Hamilton mayor Charles Bosch had lived next door to Alfred Knapp and was able to get him to confess to Hannah Goddard Knapp's murder. *From the* Cincinnati Enquirer.

The First Celebrity Serial Killer in Southwest Ohio
"I'm Pretty Popular Right Now"

Now that he was clean-shaven, some of the newspapers wanted to get some fresh photos of the "Hamilton Strangler." Knapp suddenly turned camera shy and said he would not submit to being posed. His shyness vanished when someone offered him five dollars for his effort, and so the sheriff arranged for a photo shoot in the jail dining room.

When one of the photographers greeted him, Knapp joked, "Ain't you had enough of me yet?"

"No. You're better looking since you're shaved, Knapp. We want a full-length of you this time," the photographer responded.

"I'm always good-looking," Knapp said, smiling nonchalantly.

"I'll give you to know, gentleman," the photographer addressed the room full of reporters and police, including Sheriff Bisdorf and Prosecutor Gard, "that Knapp is a fine poser. You are posing more nowadays, Knapp, than some of the popular girls around town."

"I'm pretty popular right now," Knapp said, "the wrong way."

As the photographer set up his camera, Knapp quipped, "You won't get a good picture of me if you don't get better light." He shrewdly eyed the officials in the room with a sinister look. "We better take it outdoors." The joke fell on a quiet, nervous room.

True to the photographer's quip, Knapp proved an able model, standing with ease and composure in front of the lenses pointing at him. "Not a muscle twitched," one observer wrote, "though every eye in the room was fastened on his face. He was absolutely docile and wholly obedient to the photographer. Had one who did not know Knapp's identity stepped into the room, he would have thought Knapp was a popular people's idol of some sort. Not a trace of his terrible record was about him as he stood in the pretty dining room, lounging against the draperies posing for his picture. He even smiled occasionally and replied to any little remark made to him with ease and occasionally an approach to wit.

"His hands were, of course, unsightly, but they were not nervous. They hung in quiet repose during all the time he was in the room."

Knapp's hands, according to one description, were nothing like one might expect from a trapeze artist or a strangler. One of them was apparently partly crippled and had more of an appearance of a man who did manual labor. His hands were short, fat and calloused, with prominent veins, arteries, tendons and muscles on the back. His fingers were stubby, square at the ends and bent at the first joint like those of an old baseball player. His fingernails were coarse-grained, brittle and ill-kept. Although he boasted of a strong

The press gave much attention to Alfred Knapp's hands, as in this *Cincinnati Post* illustration published after Knapp's stunning confession. Knapp said that his hands were strong from his days as a trapeze artist, a job he never really held. *From the* Cincinnati Post.

grip, Dr. Hoppe tested his grip and pronounced it weak. His left hand was so misshapen that he wasn't able to touch the top of his thumb to the tip of his pinky finger. Hoppe suggested that perhaps he would be able to strangle someone, but only if he attacked them from behind, which Knapp had said was his preferred way.

"His eyes were peculiar, in that one of them squinted slightly. Otherwise, his expression was mild, bordering on sadness," the *Sun* reported. "After much adjusting of camera, light and draperies, the picture was pronounced taken and with a farewell smile to the little crowd of reporters and officers, Knapp was led quickly away. A little child in the door was called hastily by his mother, but Knapp heeded not. He was the popular prisoner, the big man of the jail, what mattered it to him that childhood was not safe in his presence, that women were afraid to have even his glance rest upon babyhood."

Police and reporters everywhere in Ohio and Indiana started going through unsolved crimes against women and young girls to see if any would fit Knapp's profile. Some had occurred while he was in prison and were dismissed. Inquiries were even received from Denver, Colorado, regarding the unsolved strangulation murders there that occurred around the time of Mary Eckert's death. Knapp said he had been in Denver around that time, but he wasn't that particular strangler.

The First Celebrity Serial Killer in Southwest Ohio

Like a Page From a Novel

Even though Sheriff Bisdorf threatened many times to cut off press access to the prisoner, daily reports continued to come from his cell as he finished up his first week in the Butler County Jail. Knapp mingled freely with other prisoners, ate and slept well and talked cheerfully and freely to all visitors.

The *Cincinnati Post* printed a story on Wednesday, March 3, about how, in the summer of 1886, Knapp assaulted a girl at New Madrid Bend on the Mississippi River in Lake County, Missouri.

"He says he was chased by a mob bent on lynching him," reporter W.J. Taylor wrote in introducing the dramatic, detailed account, "and that he held the big crowd away with a Winchester rifle. He succeeded by saving his life in flight, making his way across the river and to safety."

The writer admitted the story "sounds like the page from some sensational crime novel," and two days later, Knapp told the *Evening Sun* that he made it all up. The reporters were so hungry for stories, he said, that he didn't want to disappoint them.

"What punishment do you believe fits the crimes to which you have confessed?" a reporter asked a few days after his visit with Herman Littleman.

"I don't know exactly," he said, "but I believe that if a sane man did them, he ought to be put to death."

"What would you think if a relative of any of your victims came into this cell and tried to kill you?

"I wouldn't blame them at all," he said. "If any of them killed me, I do not think that any of them would be blamed by anyone. When Mr. Littleman, the father of the little girl I killed in the lumber yard [sic] in Cincinnati, called on me I was somewhat startled. I turned all kinds of colors."

"How do you know you turned all kinds of colors?"

"I must have turned all kinds of colors because I felt it—I felt myself growing weak. It was a trying time to stand there and talk to that man. I really felt sorry for him, and if I had the power I would have brought back his little girl for him."

"Suppose he had pulled a revolver and shot you down?" the reporter asked.

"I would not have blamed him at all. In fact, I looked for that very thing. While I was talking to him I noticed that he had one hand in his coat pocket. I was on the alert all the time. It would not have surprised me to see a gun suddenly flash, but if one had been pulled I would have dropped to the floor and crawled out of my cell to the corridor.

"I don't want to get shot," he continued. "I was glad when the man left, and I hope that no other relatives of any of the persons I killed calls. I don't want to see them. They make me nervous."

Knapp was obviously aware of how ridiculous the news coverage had become. In a tradition that continues today in the world of the twenty-four-hour news cycle and the Information Age, the press of 1903 left no stone unturned to find stories about "Strangler Knapp." That included interviewing anyone who crossed paths with him who had a story to tell, as well as drawing out experts from a variety of disciplines to comment on the matter. Phrenologists made suppositions about his character from reports of the bumps on his head. The *Cincinnati Enquirer* took photos of the palms of Knapp's "deadly weapons with which his heinous crimes were committed" and gave them to "a prominent young society lady of this city, skilled in the art of palmistry."

The "abnormal development" of the Mount of Venus showed that his animal instincts are overdeveloped, she divined. "His finger nails [*sic*], which are bitten off at the quick, show that he has a nervous and vicious disposition," and his Mound of Mars showed that he "has a furious temper and often becomes suddenly enraged." Other features showed that he "is capable of deceit…very cunning…mentally sound…a man one couldn't trust."

The *Wheeling (WV) Telegraph* sent a palmist named Laida to Hamilton to get a smoke impression of Knapp's hands, along with those of several other inmates, which she shared with a group of her peers. This time, the impressions were unmarked, so the readers didn't know whose palms they were reading. After learning the identities of the palms, they weren't surprised to learn which were the hands of the strangler and which were the hands of the lesser criminals. Knapp's hands showed strength and power, but also a cowardice and a restless, nervous temperament that the others didn't, Laida told the *Telegraph*. "There are numerous lines…that indicate that under certain nervous conditions he might commit murder, but never under any conditions could a man of his cowardly disposition face an equal in size and strength, even if he was well-armed." They also determined that the general formation of the hand suggests insanity "from birth to death, although not necessarily insanity of a violent nature."

Laida and her students also divined that Knapp would live a long time: "He will not die in prison, but in a large building with a number of people, mostly strangers to him, around him. His life has been a terrible one and the world will breathe easier at the news of his death."

Between Knapp's lies and the stories coming from every direction, there were many inconsistencies and improbabilities in the various newspaper accounts. These arose from people eager to get their names in the

newspapers or from newspaper reporters who were either willing to stretch a truth or just neglected to confirm the stories.

On Thursday, March 5, the *Evening Sun* published a story supposedly told by Mamie King earlier that week. It said Knapp was visiting Cumminsville when the afternoon papers came out with the news of the foul murder in February of Fred Geiger's wife in Cincinnati.

"Why, Allie, ain't this terrible," she said, showing him the newspaper.

"It's horrible," he said. "Any many who kills his wife is crazy. If Geiger did it he ought to be hanged. There is no punishment too hard for a man that would chop up a woman that way." He threw down the paper. "I can't read about it," he said. "It's too terrible and revolting."

Knapp was still visiting when the story of Sam Keelor's murder of his wife broke three days later, a homicide inspired by the Geiger case.

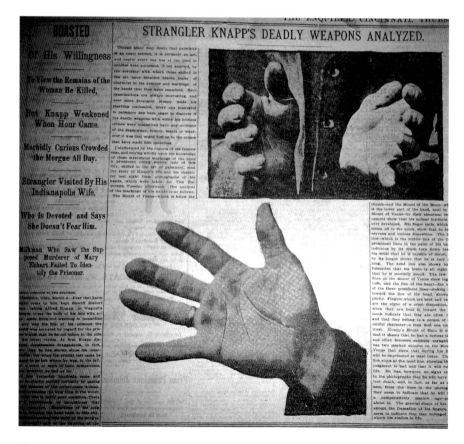

The *Cincinnati Enquirer* gave amateur palm readers a chance to make their own analysis of the Strangler's hands. *From the* Cincinnati Enquirer.

"That man has no sense!" Knapp cried and condemned the murder in the strongest of terms. "It must be awful to have a murder in the family, and I thank God that there is none in ours. I don't think I could ever hold up my head if a relative of mine was a murderer."

This story was the first mention of Knapp visiting Cumminsville between the day after Christmas and his arrest, which wasn't quite two weeks after the Geiger and Keelor murders. The Geiger murder was first reported on February 13, and Keelor's followed on February 16. Knapp would have been married just ten days to Anna May Gamble at that time, and it seems unlikely that he would have spent three days and nights away from her. And his propensity for gab makes it also unlikely that he would not have let news of his latest marriage spill during such a long visit.

It is precious, to be sure, but who made it up? Mrs. King or Mr. Reporter?

The Body and the Box

After the period of near-flooding that hampered the search for Hannah's body, the waters of the Ohio River were just starting to slack on Monday, March 2, when the ferryboat *Bellevue* started to approach the wharf at New Albany, Indiana, late in the afternoon. George Pugsley, a deckhand, was standing forward near the bow and saw something bobbing up and down in the water. He notified the captain, who sent him and two other men out in a yawl. They pulled up alongside and found it to be a naked body, face downward. The head, shoulders and legs were submerged. They looped a rope around the arm and pulled the body to shore at the foot of West Fourth Street. Everyone involved believed they had found the body of Hannah Knapp, exactly ten weeks after her husband put her murdered corpse in a box and put the box in the Great Miami River, 184 miles upstream.

The body was badly bloated and decomposed. It had no hair, and there were cuts on the face and a two-inch fracture on top of the head. The flesh was black from the neck up, which the local coroner said was a clear indication of death from strangulation. He handed it over to an undertaker for immediate embalming to forestall further deterioration and notified Hamilton authorities.

The woman was nude except for black stockings with white feet and blue tape garters. Every detail matched. Hannah had been five foot one, 105 pounds. The body was wearing a ring that Charley Goddard gave Hannah

on her twenty-eighth birthday three years ago, a half-inch-wide gold band embossed with three small birds and an owl.

The news reached Hamilton around 6:00 p.m. and "spread like wildfire," the *Evening Democrat* said. The *Cincinnati Post* put a man with Edward King and a man with Charley Goddard to accompany both to New Albany on Tuesday morning trains. Oddly enough, New Albany was one of the many cities where the Knapp family had lived between their moves—perhaps thirty of them—during the years their children were young. Cyrus and Susannah Knapp lived in New Albany when Alfred finished one of his stays at the Jeffersonville penitentiary and he joined them there, but they moved just a few weeks later.

King arrived first at 6:30 a.m. and confirmed identification by the wound on her leg and a scar on her forehead, caused by a childhood accident. While romping with Uncle Charley, she ran into a door, and a protruding key struck her in the forehead. Hamilton chief of police Gus Kuemmerling arrived at 8:30 a.m. and confirmed that the body matched the description Knapp had given. Goddard arrived at the undertaker at 12:10 p.m. The sore on her leg and a missing half-joint of a finger made the identification obvious.

"That's Hannah!" Goddard exclaimed, bending over the bloated body. "That's the murdered girl!"

He wept aloud as he left the room and identified the gold band ring and the earrings that had been removed from the body. King and Kuemmerling had a few words about the disposition of the body. King said he wanted to take the body back to Cincinnati so he could pay for the burial as no one in the Knapp family had the means.

Kuemmerling nixed the idea, saying the body needed to go to Hamilton as it was evidence, and he had the city treasurer wire $100 to New Albany to cover transportation expenses. King protested, but Kuemmerling claimed authority.

"Perhaps I can bury the body in Hamilton," King finally conceded, expressing disappointment on behalf of his wife, who was very fond of the girl.

The Butler County Commissioners said they would split the $100 reward among the three deckhands who pulled the body ashore. The body left the Hamilton Depot at 11:30 p.m. on Tuesday, arriving in Hamilton at 12:35 a.m. on Wednesday. Uncle Charley rode along and faced a crowd of more than two hundred people when the train pulled into the station, even at that hour.

Because no one in Hamilton knew which train the body would be on, the crowd would swell and wane throughout the evening, the *Evening Democrat* reported, suddenly dissipating after the departure of a train and slowly growing until the

arrival of the next. When the right train finally pulled into the station, people stood on their trunks and on tiptoes to get a glimpse of the plain wooden box that contained the casket as a team of four police pallbearers—including Captain Thomas Lenehan—removed it to the waiting ambulance of undertaker A.P. Wagner.

A large portion of the crowd followed the carriage to the morgue, hoping to be able to get a look at the bloated remains of the victim. They were disappointed. Director of Police Mason gave Wagner orders to keep the body under guard while preparing it for interment and to allow no one to go near the remains without a signed permit from him.

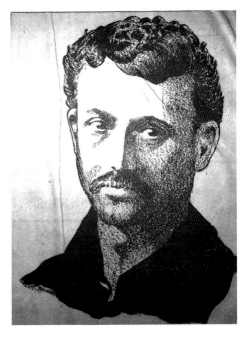

A drawing of Alfred Knapp as he appeared when first brought to Hamilton. *From the Cincinnati Enquirer.*

When told that a body had been found, Knapp said that if the floater was his third wife's corpse, they would find a bandage on her right ankle as Hannah had run a nail in her ankle two years previously while working in the candy store of Sorensen & Brown on Elm Street, and it caused quite a wound that would not heal. He said that she was wearing black stockings with white feet, and an extra stocking on her wounded leg to keep the wound from developing poison. But when Mayor Bosch went to his cell to tell him the body had been found, Knapp was incredulous.

"That's across from Louisville," he said. "How did the body get across the falls? You know yourself that is a pretty long distance for a body to travel. I don't believe they have Hannah's body yet."

A reporter asked, "Didn't you pack it in a shoe box and throw it into the river?"

"Yes, I did," he said, despondent. "But I can't see how the body got so far."

Fearing that Knapp might commit suicide as the discovery of the body ensured a trial in Hamilton and a possible death penalty, Sheriff Bisdorf had a trusty prisoner transferred into Knapp's cell to keep an eye on him.

The First Celebrity Serial Killer in Southwest Ohio

The *Evening Sun* put out more special editions tracking the identification of the body found in New Albany, Indiana. *From the* Evening Sun.

With the body now safely tucked into Wagner's morgue, Prosecutor Warren Gard was relieved to know that he would be able to try Knapp for the crime he committed in Hamilton. It was the missing link, he said, between Alfred Knapp and the electric chair.

The Strangler's Tales

The Strangler's Wife Comes to Town

Carrying a crude basket filled with fruit and laundry for the prisoner, Anna May Gamble Knapp caught the 8:05 train from Indianapolis on the morning of Wednesday, March 4, to see her husband, exactly one week to the hour since he took the same train to Hamilton in chains and under the protection of Captain Thomas Lenehan and less than eight hours after the arrival of the corpse of her predecessor.

Annie traveled to Hamilton alone, but reporters both saw her off in Indianapolis and met her at the station in Hamilton.

"I am going to have a long talk with my husband," she said to an *Indianapolis News* reporter who saw her at Union Station just before the train left. "I guess he killed those people that he tells me about, but he must have been insane. No man in his right mind would commit those crimes.

"It is true that he once choked me in his sleep," she said, recanting her earlier story. "He had his hands about my throat and I could scarcely awaken him. When I did waken him, he did not know what he was doing. It is not true that I have threatened Mrs. King, Knapp's sister in Cincinnati who is reported to have opposed my marriage to Knapp. I have threatened no one, and I will make trouble for no one. All I want is to be let alone. If they take my husband to the chair, I want to die. I am so lonely."

She was allowed to visit with Alfred in his cell for about an hour. They would not allow her to take in the fruit nor the small ornamental clock she brought him in a pretty box that smelled strongly of carbolic acid. After Sheriff Pete Bisdorf inspected the new suit of clothes she brought, she was able to take it in. When he saw her, a kindly light filled his eyes along with a flash of recognition. They were not permitted to kiss, but they clasped hands through the bars of his cell and began to talk earnestly. He said, "Hello, kid," and for the first time since his incarceration, Knapp wept openly.

"I hope they won't send me to the chair," he told her, "but things look gloomy."

"Allie, if you are sent to the electric chair, it will kill me," she said. "I don't believe that you have committed all those terrible crimes."

"Well, I've confessed to them, haven't I?" he asked.

"I would not believe it until I heard it from you."

"Won't you come to Hamilton to live so that you can be near me?"

"No," she said forcefully. "I won't live in Hamilton."

She saw how this jarred him and said, "But I want you to keep your spirits up and be cheerful. I'll come down and be with you at the trial if possible."

"They tell me you are making threats against Mamie," he said.

"I never said I would hurt her," she said. "That's a lie."

At 12:40 p.m., Annie left the jail with Colonel W.J. Taylor, a reporter from the *Cincinnati Post* (one of the few newspapers of the time to put bylines at the top of stories giving the writers credit). He took her back to the depot for the 1:04 express to Indianapolis. Word got out that she was in town, and as she left the building, she walked into a crowd of several hundred people, including a couple dozen members of the press.

"I hope he will not go to the electric chair," she told reporters. "I would rather see him go to the Columbus penitentiary for life. Then I would move to that city and live there to be near him."

The newspapers seemed somewhat sympathetic to the fourth wife's predicament. She would likely have been an unwitting victim of Strangler Knapp herself had he not been caught, but their descriptions of her carried a harsh, condescending tone. The *Evening Democrat* plainly called her "a dwarf…a child's body but a woman's face, which to say the least is not intelligent-looking…The dwarf was dressed entirely in black and her countenance, although almost without expression, showed she labored under unusual excitement…The woman has not one feature which would attract a man of even Knapp's character and the report that she is feeble minded would be readily credited by any close observer."

"She is about the size of a doll," the *Evening Sun* quipped. "Her eyes look as if they are about to pop from her head. Her face is very small and round with red cheeks. The upper lip projects and give[s] the woman the appearance of being about to cry at all times. She was very neatly dressed in black and wore a large black hat and veil. Taken altogether, she is one of the most peculiar women seen in Hamilton for a long time."

The *Post*'s Taylor, however, walked Annie to the train and questioned her along the way. His description was a little more kind: "The little woman seems utterly heartbroken over the predicament of her husband. She is slightly built, with irregular features, and has not a very intelligent appearance. However, she manages to keep in the foreground in all her conversations her belief that her husband is insane and manifests ideal sympathetic emotions."

She told the reporter that she wasn't quite finished with Alfred, but she had to catch her train.

"I would so much like to see him alone and have a private talk with him," she said. "Allie has something secret on his mind which he wishes to tell me. I do not know what it is, but it must be something very important to me."

The reporter told her that they would not let Knapp talk with anyone alone.

"Oh, well. If they won't let Allie talk to me privately, I am sure he will not tell anyone else what he has to tell me," she said. "Allie is a queer fellow and

sometimes I must confess that I do not understand him. I can look back now and recall many things that make me think that he has always been crazy. I wonder now that I did not realize before this that my husband was an insane man. In spite of the fact that he has confessed all these terrible things, and in spite of the fact that I believe he killed Hannah Goddard, I am not afraid of him. Yes, I heard that he said that he might have killed me, but I don't believe that he said it."

"Oh, he said it all right," the reporter told her. "Many people heard him."

"Well, I don't believe that he would have killed me. I would be willing to take the chances and live with him in spite of it all. He was good and kind to me and did everything that he could to make me happy. Well, I am sorry that I have no funds to help him, but I shall save all the money I can and send it to him."

Just before she boarded the train, she asked a favor of the reporter: "Tell Allie, for me, if I do not see him again, that if he is sentenced to the electric chair I will, on the day he is killed, walk to the White River Bridge near our home in Indianapolis, and throw myself in. Tell him I cannot live without him, and tell him I will do it when no one will be watching me."

The visit left Knapp feeling blue when jailers brought him the clock Annie carried with her. Although it smelled of carbolic acid—one of the preferred suicidal poisons of the era, readily available as an antiseptic—a thorough examination turned nothing up.

Taylor went back to the jail to deliver Annie's message.

"I hope she does not do that," Knapp said.

Sadie Wenzel visited Knapp after Annie left, and Knapp said he made the confessions out of bitterness toward the Kings and made no attempt to conceal his feelings.

"They told on me," he said, "so I just thought I would tell everything, and if they were looking for disgrace, they could have the disgrace of it all. I hope they are satisfied now.

"I would like to have had the money to bury Hannah," Knapp said, "but as the Kings have butted in and say they are going to bury her, they can do it."

Strange Visitors

Knapp received another surprise visitor that day, milkman William Woefle, the only eyewitness to the Mary Eckert case. On the morning of her murder,

just a few hours before the body was found, he had served her a ladle of milk. Eckert had asked him the day before whether he knew of any jobs she could take, so they spent some time talking about that. While they chatted, Woefle had seen a dark stranger, believed to be the murderer, lurking at the gate waiting for him to leave.

Woefle walked into the cellblock of the Butler County Jail with a team of newspaper reporters and Director of Police Mason. Knapp noticed that he was under scrutiny by the milkman, saying, "Who is that man looking at me so hard?"

"Why, Alfred, don't you know him?" Mason asked.

"I don't know whether I do or not," he said.

After the interview, Woefle declined to positively identify the prisoner as the man he saw in front of the Crouth house on Walnut Street the day of Mary Eckert's murder. It had been nine years, he explained, and his memory had become a little fuzzy. He did not want to convict a man unless he was absolutely certain. He did say, however, that there was a great similarity between Knapp and the mysterious stranger.

"I used to think that I would never be afraid of any man, but I got the one shock of my life on that morning, when I saw the man glaring at me so vengefully from the sidewalk," Woefle said. "I became so uneasy that I told the girl at that time that I was afraid of him and that is why I asked her if he was one of her friends. I was talking to her about a position and it was that conversation that caused the man to watch us so closely.

"When I asked Mary Eckert if she knew the man, she looked out of the door at him, and then with a smile replied that she did not. I think she knew him and she evidently thought I believed the same, but I left the house a minute later."

While Knapp received his visitors, Wagner's morgue prepared the remains of the third wife for burial. Police Chief Gus Kuemmerling was amazed at the improved condition of the body and gave kudos to the New Albany coroner and embalmers. Her face was now recognizable.

"The cold water and ice helped materially in preserving the body of Mrs. Knapp while it was in the river," he said. "Had it been warmer weather, the body would have been too badly decomposed for recognition, but I believe the body escaped from the box and became frozen in the river ice and was thus preserved."

Still, when they laid the body out in an open casket for the funeral services, Wagner placed white handkerchiefs over her face and hands and sealed her under a glass lid. The morgue's viewing room was open from 4:00 to

10:00 p.m. on Thursday, March 5, to accommodate the hundreds of curious mourners, almost entirely women, just as at the funeral of Bertha Keelor, the murdered wife of Sam Keelor, not even a month earlier. They began arriving at 1:30 p.m., waiting in the cold outside the mortuary.

Three women and a girl, evidently representing three generations, stood by the casket when a *Sun* reporter walked into the viewing room. The eldest woman asked, "Are you the undertaker?"

"Yes, madam," he lied.

"We would like to look at the body," she said.

"There it is," the reporter said.

"Yes, I know," the woman said. "But we would like to see the head. Why don't you take off the bandages?"

"I'm afraid you could not stand the sight," he said.

"Oh, yes, we could," she said. "We want to see it so badly."

"I'm sorry, ladies," said the reporter, "but I cannot remove the glass lid."

"Well," the elderly woman said. "We can see part of her arm anyway. It looks just like bisque, doesn't it?"

Hannah Goddard Knapp was buried in Greenwood Cemetery six plots away from Bertha Keelor, who on February 15 was murdered in her sleep, also by her husband. Knapp requested to go to the funeral, but it was already done by the time he asked.

A PUZZLE TO HIS ATTORNEYS

On Friday, March 6, the day after the milkman's visit, Knapp had a meeting with his new attorney, former Hamilton County assistant prosecutor Thomas Darby, assisted by John Thomas Jr. Darby had vast experience in criminal law as an assistant prosecutor for Hamilton County (Cincinnati). He was well known for his intense earnestness, which he also applied to defending clients when he left the prosecutor's office for private practice. His doggedness could also be a detriment in that he frequently worked himself into ill health and would have to take a restful break after particularly grueling cases. This one promised to be one of the most grueling of his illustrious career.

Darby said that his new client was a puzzle to him, and the more he thought about the case, the more puzzled he grew. It was, apparently, Knapp's habit of talking so casually about his crimes that caused the attorney's confusion, compounded by the fact that of the previous twenty-four years of Knapp's life, seventeen were spent in jails and prisons. His few years of freedom were occupied by pursuing women and girls, to either flirt with, marry, assault or kill.

Yet Knapp was no stranger to Darby. In fact, Darby prosecuted Knapp in 1890 for an attack on Amanda Krustaner, a young schoolteacher in Cincinnati's Burnet Woods.

"He leaped from his wagon while driving along Clifton Avenue one day and ran up to a woman in the park," Darby said when the case was concluded. "Although a number of men were at work in the park and in full

view, Knapp seized her by the throat and choked her until she fell senseless. He then released his grip and rushed back to his wagon. He drove off before the spectators could come up with him. As his name was on the wagon in large letters, he was soon apprehended."

"That girl is lucky," Knapp said. "I intended to strangle her. When I met her on the avenue in the park the impulse to kill her came over me and I was going to strangle her and I would have done so but she screamed and fought so that I lost my nerve. Her cries and the fight she made saved her life. Had the officials known that I was bent on murder, I believe that they would have given me a heavier dose."

Knapp was sentenced to four years in the Ohio State Penitentiary in Columbus for the assault.

"His time was shortened because of good behavior," Darby said, "but the day before his release he attacked a young woman in the penitentiary in the same manner and was held to serve out his full term."

Among his many notorious crimes, a clerk at the Butler County Board of Elections uncovered yet another, albeit far less brutal: election fraud. The clerk found evidence that Knapp voted illegally in the previous November elections. He registered in Precinct A of the Fourth Ward on October 16 and swore that he had been a resident of Ohio for seventeen months, when just four months earlier he had been a guest of the state of Indiana prison system.

No charges were filed.

Witness for the Defense

Sheriff Peter Bisdorf finally put a gag on Knapp that seemed to stick and wouldn't allow him any further visitors other than his lawyers. His jailers reported that the prisoner seemed unconcerned about anything, confident that an insanity plea would save his life. He spent his days cheerfully playing euchre with the other prisoners, reading and eating and sleeping like a man with a clear conscience.

Knapp would soon enough get a moment in the limelight, even before his trial. On March 10, he was served a subpoena to testify on behalf of Joseph Roth, the man charged with assaulting the Motzer girls, a heinous attack that police and press both thought more up Knapp's alley than the fidgety Roth.

Despite their client having been tracked down by a pair of famed bloodhounds brought to Hamilton from Dayton and identified by the

young victims after their recovery, Roth's attorneys believed that the strong resemblance between Knapp and Roth might just be enough—along with Knapp's current notoriety—to plant the seed of doubt in a juror's mind. Anna Motzer, the mother of the girls, said that Knapp had been in their butcher shop on the afternoon of the assault. Knapp himself confessed to being the "tin badge detective" who told Mrs. Motzer that he would come back in disguise.

Speculation was that Knapp was afraid of a lynching, and knowing about the demonstrations around the jail on the night of Roth's arrest, he maintained his innocence of that particular horror, even though his alibi proved to be one of his lies. But since he had confessed to everything else with casual ease, the press (if not Knapp's lawyers) were hoping for a dramatic courtroom confession of the Motzer assault from the hapless Knapp.

Darby was on to their tricks and objected to Common Pleas Court judge Edgar A. Belden, saying that that the subpoena was improper because Knapp would soon enough be on trial for his life and it was evident that placing Knapp on the stand was purely for sensationalism. Belden allowed the subpoena to stand, but Darby accompanied his client to the courtroom that Friday to make certain that he wasn't badgered into confessing to yet another crime.

The trial of Joseph Roth turned out to be a bitter battle between Prosecutor Warren Gard, with Anna Motzer at his side, and Allen Andrews for the defense, drawing a large crowd to the courtroom each day. Compounding interest in the case itself was the possibility that "Strangler Knapp" would make his dramatic witness-stand confession. Still, those who were there silently clung to every syllable in evidence, the jurors leaning forward in their seats. For much of the testimony, Roth hung his head and picked at his fingernails, "as if ashamed and ill at ease," the *Democrat* said.

Chief among the dramatic moments was the testimony of Stella Motzer. When the prosecutor asked her to point out the man who had cut her on the head, she climbed down from the high seat of the witness box and wound her way among the chairs in the silent courtroom to place her hand on Roth's shoulder without a trace of fear. She did it twice, once in rehearsal without the jury so Judge Belden could determine her reliability, and each time Roth watched her approach and felt the touch of her hand without flinching, looking at the girl with a little smile. Her voice was so soft that Belden had the bailiff move the witness box closer to the jurors.

Gard asked her about her name and age and then if she remembered the night she got hurt. The girl said she did, that she and her sister were at

Koerber's grocery when Joe Roth offered them candy to go into the alley with him. They went to the far back of the alley by a white shed.

"What did he do to you?"

"He cut me on the head," the child answered and took off her cap to point at the scar. She said Roth then hit Hattie, and she ran back to her aunt's home.

"Can you show these gentlemen who it was cut you with the knife?"

The child got down and put her hand on Roth's shoulder. He looked astonished.

On cross-examination, Stella revealed that she told her aunt, "It was a bad man" and didn't know who it was.

"Who told you it was Joe Roth?" Andrews asked.

"I thought about it."

"And then you decided it was Joe Roth two or three days afterwards, didn't you?"

"Yes."

When the prosecutor called the owner of the bloodhounds to the stand, Andrews objected and started making a speech. Belden interrupted him to remove the jury from the room before they argued the admissibility of the dogs' testimony through their handler.

"Who can cross-examine them or put them under oath?" Andrews asked.

Belden cited a decision of a judge in Alabama who admitted the work of dogs as evidence.

"That's just it," Andrews said. "I would expect to go to Alabama, where they trail human beings with dogs to get such decisions."

Gard said that Andrews's remarks were alright "from a jocular standpoint," that everyone knows dogs can't be sworn in, but if history showed the dogs were possessed with the proper skills, their work could be used as evidence, albeit not evidence of the greatest weight, but that the question of weight would rest with the jury. Let the jury decide if the dogs were reliable, Gard argued.

They bantered for an hour before Belden overruled the objections and called the jury back. The story of the dogs going to Roth's house was told twice, once by the handler and once by Captain Thomas Lenehan, with Andrews objecting frequently throughout. At the end, he moved that the testimony be stricken. Belden overruled.

Roth was the first witness in his defense. He seemed calm as he told the court that his family owned three acres and three lots that he was gardening. He had no other trade but would do manual labor for other men. He said he helped build the courthouse they were in while he was

a prisoner. He said he was a member of a church and attended regularly. He said he had known the Motzers for several years and had seen the girls around when he would take them produce from his truck or buy meat from them but had never paid particular attention to them.

Then he told the story of the events of September 16, 1902, admitting that he called the police a bunch of toughs when they followed the dogs up to his room. When he told Gard that no one told him why he was under arrest, Gard asked, "What did you think they were arresting you for?"

"I thought they were arresting me for sassing them," he said.

"Now, Joseph, tell this jury if you assaulted those girls," Andrews demanded.

"No, sir, I did not."

"Were you in the alley that night?"

"No sir."

"Did you cut this Stella Motzer on the head?"

"No, sir, I did not," he spoke firmly, without a tremor.

During cross-examination, Roth denied making a practice of holding the little girls on his lap but said he did set one of them on his knee one night in the presence of the parents.

Gard asked him how many times he'd been arrested, and he evaded a direct answer, saying only that he'd never been convicted of anything. He said he did get into a quarrel with his father that came to blows, but it was only because he was intervening on his mother's behalf when John Roth was about to strike her.

Word got out that Knapp would be called to the court on Friday, March 13, so it was even more crowded than usual when Strangler Knapp walked into the courtroom with the relaxed air of a man going to work. He was dressed in a new serge suit, which some reported as dark blue and others as black, tailored to show off his muscular physique, along with a white shirt with a standing collar and a pretty pale green tie. He carried a white handkerchief with a pink border, an affectation popular with distinguished gentlemen at the time, making him without a doubt the nattiest person in the room.

"When together in the courtroom," the *Democrat* reported, "the resemblance between Knapp and the defendant was marked. Knapp is darker and has black hair and eyes while Roth's are a chestnut brown. They look enough alike to be brothers."

Judge Belden told Knapp that he was not obligated to answer any questions put to him and could decline to answer any and all if he chose. His testimony, however, proved to be anticlimactic. There would be no

confession from the witness stand, much to the dismay of all. He knew the corner of Central Avenue and Walnut Avenue and had been there more than once but could not fix any specific times or dates. He said he did not know the Motzer family.

Andrews asked him if he knew anything about the assault.

Knapp replied, "I heard of it, but know nothing about it."

When Andrews asked Knapp about various other streets in Hamilton and some of the saloons in them, the witness started to get testy, saying, "I don't know the streets by name, and I don't know of any saloon down there."

"Have you ever been in Hensler's barroom?"

Knapp's temper flared. "I tell you I don't know of that saloon and was never in it."

"Were you in the neighborhood on the day of the assault?"

"Yes, I was in Dr. Krone's office."

"What time was that?"

"I don't know. I guess it was during his office hours. They are between seven and eight, ain't they?"

After he left the doctor's office, he went straight home to Sycamore Alley, where he lived with his wife, Hannah, and her uncle, Charles Goddard.

"Did you call at the house of the Motzers a few days after the assault and claim to be a detective?"

"I decline to answer that," the witness said, putting on a distant look.

"Did you state that Mr. Roth was innocent and that you can clear him?"

"I decline to answer."

Knapp continued to look perfectly at ease, gazing carelessly around the room as if looking for people he knew while the attorneys argued over the admission of testimony.

Andrews tried to ask more questions, but Gard's objections were sustained. Alfred Knapp left the courtroom without doing anything to affect Roth's case in any direction.

After a parade of witnesses testifying to Joe Roth's good character, including the pastor of his church, the jury took only thirty minutes to return a verdict of not guilty.

"I must run home and tell Mother the good news," he said in parting.

A Puzzle to His Attorneys

Wife Murderers

The courtroom was packed even tighter on Monday morning, March 16, for Knapp's preliminary hearing in the Mayor's Court. He wore the same serge suit and green tie and again appeared indifferent throughout the proceeding. Only Charles Goddard and Police Chief Gus Kuemmerling testified. Darby protested, saying he was willing to go through the whole case right then and seemed especially eager to go after the confession. Mayor Bosch ruled that the confession was made "without duress, undue promises or persuasion," and there was enough testimony to hold Knapp without bail to await a grand jury.

Knapp wore a conspicuously large white soft hat as he passed through the crowd gathered on High Street. He kept his hands in his coat pockets and held his head so far down that his chin touched his chest. Someone in the crowd yelled, "Lynch him!" The two officers paused a moment to eye the crowd and then double-timed it back to the jail.

Prosecutor Gard and Judge Belden convened a special grand jury on March 23 to hear the cases of Alfred Knapp and Samuel Keelor. Both were indicted on charges of first-degree murder, accused of killing their respective wives, and both were served as they ate their dinner in the Butler County Jail. Keelor didn't look up from his dinner but just laid the paper aside. Knapp, who was playing cards with four other prisoners, said he was shocked.

"So they indicted me, did they?" he said, casual as ever. "Well, what else could you expect from a job lot of jays like those old farmers? As soon as I laid my eyes on that bunch I knew it was all up with me."

"You know you confessed, Alfred?"

"Yes, I know I did, but I expected to get off lighter than that."

"What did you expect?"

"I expected murder in the second degree."

"How's that?"

"Well, I'll tell you. They got to prove I planned to murder Hannah. It's got to be proved to be premeditated and all planned out before you can indict a fellow for murder in the first degree. They can't prove that on me. I was asleep when I commenced to choke Hannah, and I didn't plan to murder Hannah."

"What kind of plea are you going to make, Alfred?"

"Oh, I don't know," he said. "My attorneys will fix that. But one thing I'm sure of, they'll never send me to the electric chair."

With those two now served, the Butler County Jail had three men indicted on first-degree murder charges: Knapp, Keelor and Fred C. Wellner, a Miltonville farmer charged with beating to death one of his farmhands in

1902 in order to collect insurance money. (The farmhand happened to be one of the famed feuding Hatfields, some of whom came to Butler County to aid in the investigation.) What makes this population of murderers remarkable is that there had been no indictment of first-degree murder in Butler County since George Schneider was hung for killing his mother in 1884. Before Knapp's case would be entirely settled, there would be a fourth—another wife killer—added to the list.

It also meant that Prosecutor Warren Gard would have to prepare Wellner's case first (which would be reduced to second-degree murder) and then Keelor's before getting to Knapp.

Knapp and Keelor also answered their indictments on the same day, both with "not guilty" pleas. Knapp's freshly shaven, tailored-suit appearance was even more striking this time because his case followed that of Sam Keelor, who was not only dressed in a coarse brown frock coat but also had grown violent red whiskers, his neck crudely bandaged to cover the self-inflicted wounds where he tried to slit his own throat. Compared to that sad sack and the other loungers jammed into the room, Knapp, with his pink-trimmed handkerchief, seemed quite the dandy. Indeed, even though Keelor's case came first, the newspaper accounts led with Knapp and noted his subtle interactions with the crowd. The out-of-town papers barely mentioned Keelor, if at all.

The Reluctant Recluse

Although Sheriff Peter Bisdorf had put an end to the daily interviews with the prisoner, there were occasions where the press got to peek in on his status and the family drama outside of the jail. Having spent most of his adult life behind bars, Knapp was thoroughly "prison wise," and removed from the temptations of women, he seemed to get along just fine. Except for the one outburst that lengthened his stay at the Ohio Pen, he was a model prisoner by all reports during every incarceration.

While Knapp was awaiting trial, his father, Cyrus J. Knapp, died of aseptic meningitis, an inflammation of the brain covering, on April 27 at Sadie Wenzel's house at 1561 Dudley Street in Cincinnati. He had been admitted to the hospital on April 9 to have an abscess removed from his left ear. At first, he seemed to be recovering but remained in a state of delirium as the infection spread to his brain.

During his illness, he talked incessantly about Alfred, declaring over and over, "My poor boy is not in his right mind." He also seemed aware of the fatal nature of his illness, lamenting that he would not be able to attend the trial.

The entire family was with him at the end—his wife, Susannah; his daughters, Mrs. Hill and Mrs. Wenzel; Cyrus Jr. and his wife, Ida—with the exception of the King family. Mamie did call on the house the day before his death. Sadie grudgingly let her in, still bitter that Mamie and her husband insisted on turning Alfred in to the police rather than handle his behavior as a family, and there was a decided chill between them, even as their father lay dying.

"See what you've done," Sadie charged as Mamie wept at his bedside. "This is your work."

Mamie made no reply.

Cyrus Knapp Sr. was sixty-three years old and a Civil War veteran. He had never done well financially, his obituary read, but he was an easygoing man who took life as it came and didn't worry much about the future. His obituary also said, oddly enough, that he and Susannah had known each other all their lives. Said the *Cincinnati Enquirer*:

> *They were babies together and both were nursed by the same mother. They grew to manhood and womanhood together and have never been away from each other for a longer period than six months in 62 years. Mrs. Knapp is only a few weeks younger than her husband. She even went with him when he enlisted in the war and she served on picket duty. They slept in the same cradle as infants and were an example of connubial happiness that is rarely found.*
>
> *The awful crimes of their son have not only been the cause of the old man's death, but the mother, although faithful to her boy, has been broken in spirit and suffered in health from the horrible disclosures.*

Alfred Knapp received the news via a telegram from the *Enquirer* to one of its reporters, who went to the jail at 10:00 p.m. to see if the prisoner had heard yet. Deputy Sheriff Luke Brannon, a popular law enforcement officer in the county whose heroics in another case would soon earn him election to sheriff, allowed the reporter to break the news and accompanied him into the dark, silent jail to Knapp's cell.

"Poor father," Knapp said. "It was not three weeks ago that he came to see me. Luke, can it be arranged that I can go to the funeral?"

Brannon told him that wasn't likely. Knapp remarked that his father should not have had that operation, suggesting that he had advised against it.

The First Celebrity Serial Killer in Southwest Ohio

As Brannon and the reporter walked away, Knapp commented after them, "This is a sad week for me. Thursday, I shall be forty-one years of age."

The family drama reared up a few weeks later when Mamie King took the family members' bad behavior toward one another to the Cincinnati Police Department. On May 4, Mamie, wearing a small photo of Hannah Goddard Knapp in a pin on her collar, went to police headquarters to lodge a complaint against her siblings, charging that Sadie and Cyrus Jr. were jealously guarding their mother and would not allow her to step foot on the threshold of the Knapp home. She said that when she called there the previous Saturday to visit their recently widowed mother, Cyrus shook his fist under her nose and said, "Don't you dare come in here. You are responsible for the death of Father."

When Sadie joined the fray on the front steps and refused to let her in, Mamie sought the protection of a beat patrolman, who accompanied her back to the house and helped her gain entrance. Mamie said her mother was glad to see her. Furthermore, she said it was only by the "exercise of diplomacy" that she was able to attend her father's funeral. She felt so threatened that she wisely stayed in the background, she said, and avoided a scene.

The same morning that Mamie made her complaint, Sadie took her mother to Hamilton to visit Alfred for the first time since her husband's death.

"Mother, don't worry any," he comforted her. "They have no case against me."

Sadie and her mother assured him that they would stay in Hamilton during his trial and sit with him every day.

A few days later, a reporter from the *Evening Sun* accompanied a newly appointed grand jury on an after-lunch tour of the jail, a Butler County custom. Most of the prisoners stayed in their cells to avoid the glares and stares of the jurors, but Knapp "marched boldly out into the corridor and stood in the light for all who cared to take a look at him," the *Sun* reported. "He was not in the least abashed by the stares of some of the crowd and answered every question put to him readily and with evident pleasure."

His jailhouse clothes made him look much more rugged and powerful than the tailored suit he wore when last seen publicly. The *Sun* reporter thought he looked heavier, but Knapp said he had lost twenty pounds since his arrest.

"You know I've had considerable trouble in the last week or so," he said, citing his father's death. "I haven't gotten over that."

The strangler said that he had just gotten a letter from his wife, who said she would stick by him.

A Puzzle to His Attorneys

"I wish I was out of here, but while I'm here I wish some of you fellows would bring me something to read," he said. "I have been pretty good to you boys."

Knapp seemed to thrive in jail, perhaps because there weren't any women around to tempt and torment him, or maybe because the strict regimen gave his life order and focus. With a few exceptions, his behavior behind bars was exemplary, and he was even a leader among that population. His notoriety and force of personality—not to mention his vast experience residing in correctional facilities—had made Knapp the self-appointed governor of the second tier of the jail. During his stay he set a number of rules, which included prohibitions against spitting on the floor, vulgar or profane language, making noise after 3:00 p.m. and failure to clean the bathtub. Infractions would be brought before a kangaroo court, Judge Knapp presiding, which seemed to be more for amusement than an actual brute display of power. "He never had an opportunity to enforce obedience to his code because the prisoners were all models," the *Sun* said.

In an interview with the *Hamilton Daily Republican* published on May 12, Knapp casually recanted his confessions, bragging that the police didn't have "one positive piece of evidence against him."

"But your confession?" the reporter asked.

"Why that doesn't amount to anything," said Knapp. "There is nothing in it. I wrote that confession simply to satisfy the police and to give the newspapers something to print. The officers kept at me for a confession so long and wanted it so bad that I thought I'd give it. I guess I did, don't you? The newspapers made a lot of money off me. The fact is, I had nothing to do with all those murders I confessed."

Whatever the dramatic impact of Knapp's confessions, whether or not he committed those crimes would prove to be a moot point from a legal point of view. Cincinnati's police chief said that he put men on the relevant cases, reviewing old evidence, but there was no case against Knapp and not much chance of securing new evidence.

"It would be very hard to convict this man," the chief said. "Unless additional evidence is secured I cannot see how this man could be convicted of any of the crimes."

The First Celebrity Serial Killer in Southwest Ohio

Seating a Jury

By the time the long-awaited trial began on June 23, Paul C. Wellner had been acquitted of the murder of his farmhand. Samuel J. Keelor was found guilty of murdering his wife, received a death sentence and was awaiting his appeal. The latter case boded particularly poorly for Alfred Knapp. Like Keelor, his best defense was that he was sleepwalking and didn't know what he was doing until the dastardly deed was done.

"The verdict in the Keelor case simply overcame me," Knapp would say during a lull in the proceedings on his own fate. "Had Keelor been my own brother, I could not have felt worse. To tell the truth, the effect of the verdict in his case was because of the possible result of my own trial."

Nevertheless, Knapp made the expected dramatic entrance. He wore a knot of black crepe on the left sleeve of his dark blue coat in mourning for his father and a photo pin of Hannah Goddard Knapp on his lapel.

There were mixed reviews in the press as to his appearance. The *Sun* noted that he was so nervous he nearly fell over some chairs while walking around the table to take his seat. "The strangler looks bad," it declared in a concerned tone. "His face has the prison pallor which makes him appear in bad health to those who knew how swarthy he was when he was arrested. He was not as nonchalant as on former occasions and did not seem to be at ease for some time."

His hair had been cut short, revealing the horseshoe-shaped scar on his right temple. "There were several women in the audience who turned away at the sight," the *Sun* said.

The *Democrat* said he was pale and not as heavy as he was when he was arrested. It was reported that he seemed unconcerned about the hubbub of getting court in order but calmly sized up the crowd.

Neither his mother nor his current wife nor any of his sisters were in attendance. Sadie had written him a letter saying she would be up in a few days. Knapp urged his lawyers to bring his wife Annie in from Indianapolis, but they would not.

The selection of a jury proved to be a tedious affair. The lawyers went through the first venire of thirty-six names the first day but succeeded in seating only three jurors. Illnesses and business pressures were the more common excuses. One juror had "defective hearing." Judge Belden issued a second venire, this time of sixty names.

Knapp found the tedium overwhelming.

"I believe I'll collapse just like the doctors said I would when the trial is over," he said that evening. "I felt nervous yesterday and could hardly eat any dinner. Another thing that worries me is that I have not heard from my wife

in Indianapolis for ten days. I have written two letters and a postal card and none of them have been answered."

He clearly enjoyed the attention from the ladies in the spectator's area, however. Even as the crowds waned as the slow motion of the legal process overpowered the thrill of seeing a murderer, the girls still came, some of them taking days off work, to hear the testimony and try to catch a glimpse of the alleged wife strangler. The *Cincinnati Enquirer* noted a morbid flirtation between the strangler and a group of a half-dozen women in the doorway of the crowded courtroom.

"Three of them sat down just back of me," he said, "and I heard one of them say, 'That's Knapp.' I turned around when she said that and smiled at her. She almost went through her chair."

On Tuesday, they seated seven more men but lost one from Monday, so they ended the day with nine in the box. Darby asked for a day off, and the court granted it as it would allow Sheriff Bisdorf a little more time to round up the next venire, another sixty names.

By Thursday morning, Knapp's nerves began to settle, and he took on a more somber mood as the court proceedings drove home the reality of his situation.

The Butler County Courthouse as it appeared during Knapp's trial. The cupola would later be replaced after a devastating fire in 1912. *From the* 1895 Atlas of Butler County.

"I'm not so nervous as I was Monday, but I will not eat any dinner because I am worried about the result of my trial," he said. "I expect my sister, Mrs. Wenzel, up this morning. I cannot understand why I have not heard from my wife in Indianapolis…I shall send her another postal card from the courtroom today, as I don't believe she received my other letters and postal card."

Reporters tried to track down the absent Mrs. Knapp, but she had vacated her 630 Indiana Avenue address. Her foster father did not know where she was but said he thought she was still in Indianapolis.

The additional sixty names lasted through early Friday evening. Judge Belden had another thirty names drawn for a session on Saturday, which was more crowded than usual since it was the weekend. More than four hundred people jammed the streets, and the courtroom was again packed. Knapp spent a full fifteen minutes sitting on the arm of a chair, sizing up the crowd. But a jury was still not seated, although there was a glimmer of hope that one could be soon as the defense had used up its peremptory challenges and the prosecution was down to one. Belden ordered another venire of thirteen and adjourned court until 10:00 a.m. on Monday.

There was thus a collective sigh of relief at 11:15 a.m. on Monday when the last juror was empaneled and the court could get down to presenting the evidence in the case of the *State v. Alfred Andrew Knapp*.

From the Cradle to the Gallows

Prosecutor Warren Gard first called Charles Goddard and Edward King, whose testimony brought a tear to the strangler's eye. Then he called Hannah's aunt Linda Sterritt and her husband, William; the landlord Charles Datillo, who took some of Hannah's clothing in exchange for back rent; the liveryman who rented him the wagon; and the mail carrier who saw him sitting on a box in the back of the wagon.

The King family decided to make a Hamilton appearance on Tuesday morning. Edward King held forth for a time on the courthouse steps, declaring Knapp's insanity and saying that his own wife would have been Knapp's next victim even though she was at one time his favorite sister. His wife was an invalid, King said, and he wasn't sure that she would be able to endure the ordeal of testifying in this case. King said he recently learned that hereditary insanity ran through the Knapp family, but Alfred's murderous career should be ended anyway, and a permanent imprisonment would be just the thing.

A Puzzle to His Attorneys

Mamie King accidentally came face to face with her brother as he was being ushered into the courtroom. She collapsed immediately from the shock, not having seen her brother since his arrest, and was taken to Prosecutor Gard's office to recover.

The second day of testimony first saw the junk dealer who sold Knapp the box behind the Red Trunk store; Hannah's relative George Cooley, who saw Knapp driving the wagon; and Captain Thomas Lenehan. The only real surprise to those who had been following the case was the revelation that Hannah Goddard Knapp was a distant relative of the man who arrested her husband for her murder. Lenehan said that Hannah called his mother "Aunt Kate."

When Mayor Charles Bosch took the stand, Gard submitted the confession as evidence. Although Darby objected, the court admitted it, but it was not presented to the jury.

Gard surprised everyone by resting his case at 4:30 p.m. on Tuesday, after less than two full days of testimony. He reserved the right to call two more witnesses who had not yet arrived in Hamilton.

The proceedings so far had failed to yield many surprises or new information besides what had been reported in the papers. But there was plenty of drama on the way, beginning Wednesday morning when Susannah Knapp, mother of the accused, took the stand as the first witness for the defense. Dressed in mourning clothes, she told of her son's life without once looking at him. Knapp wept softly the whole time, his head down and his eyes covered with his big hands.

First, she told how the family moved around a lot when the children were little. They lived three or four times in Indianapolis, twice in Cincinnati and for varying lengths of time in various Indiana and Illinois towns: Wheeler, Moline, Rock Island, Terre Haute, Fort Wayne, Madison, Jeffersonville, Greensburg and New Albany and also Louisville, Kentucky.

She said when Alfred was very small, he was a polite, obedient, tenderhearted little boy. Then she said his behavior became erratic, ugly tempered, cruel and untruthful after being kicked in the head by a colt and lying unconscious for a day and a half. Darby had his client stand up and show the jury the scar the accident left on his head. She told about him falling twelve feet from a porch two years later and suffering from brain fever for a long time after. For months, he would awaken in the night and she would apply cold cloths to his forehead. She described the fainting spells and the fits where he would become hysterical and seem to not know anyone and how he would grind his teeth at night in between the moaning and screaming in his sleep from the pain. She said he once climbed out of the

bedroom window in the middle of the night and disappeared for three days. She said when he finally started school at age nine, he was hit on the head with a baseball bat, causing another injury that had him confined to bed for months. When he finally started going to school regularly, the teachers sent him home for being dull and stupid.

At thirteen, Alfred ran off with an accordion to join Forepaugh's Circus. When he came back three days later, he said he had been kidnapped. Then he said his name was really Adam Forepaugh and insisted on going back to the circus. After that, he started showing an interest in church and said he wanted to preach and teach Sunday school and fill in for the minister when he was ill. Then he ran away from home again, and when they found him, he was in the Cincinnati Workhouse doing time for petit larceny.

He was in and out of jail and prison a lot after that and eventually joined the family in New Albany, Indiana. When the family moved out of that house, he stayed in the vacant building for several days, joining the others in their new house only when he wanted to get something to eat.

He was about twenty-five years old when the family moved to Cincinnati, where he picked up the nickname "Loony" Knapp, which he kept for a long time. When he married Jennie Connors, he said he wrote a play called *The Angel in the Barroom* and made a large pair of wings out of cardboard for Jennie to wear so that she could fly. When she refused, he got mad.

Although Darby kept Susannah from talking about it in her testimony, Knapp also claimed to have written another play called *From the Cradle to the Gallows*, which seemed a lot like Knapp's life story.

"It portrayed the incidents in the life of a man who was impelled by a perverted will to commit one crime after another until he met his fate on the gallows," Darby said after the case was concluded. No one believed that Knapp had actually written any plays, although he did make an attempt to hire actresses to perform in them.

During the noon recess, Sadie Wenzel fainted in the law library. A crowd gathered for a moment, but court officers made them disperse.

Susannah Knapp continued to testify until 3:30 p.m., and when she was finished, she took a seat at the defense table next to her son.

The defense had a letter read into the record from Martha L. Marshall, a teacher in Madison, Indiana, who said that Knapp had been one of her pupils. She said he was "a bad boy, unruly, stupid and had no moral sense," who was troubled with headaches, dizziness and fainting spells; had little or no willpower; and was not responsible for his acts.

A Puzzle to His Attorneys

Cyrus Knapp Jr. told the story of his last trip to Hamilton to see Alfred and Hannah on December 21, the day before her murder. His mother, Sadie and Sadie's husband, Charles, were with him. They carried two baskets of provisions for them because they had heard they were down on their luck. Alfred behaved strangely the whole time they were there. He would talk to no one and sat most of the time with his head in his hands. When spoken to, he would start suddenly and then lapse into a dreamy state. At one point, he started talking about how he was going to be the next mayor of Hamilton, saying that everything was all fixed up to get the job.

After the day's session was over, Knapp asked if he could have a visit with his sister Mamie, so they were brought together for a tearful reunion in the witness room. Sadie refused to go in.

Charles Wenzel made his first live appearance in the drama in Thursday's lead testimony. He said he saw Knapp in Hamilton on December 21 as part of the party delivering baskets of provisions to the hard-luck relative. Knapp had a black-and-tan mongrel that he said was worth between $100 and $200 and a $0.25 piece of jewelry he claimed was worth $50. Knapp also told him about his mayoral aspirations but declared he was too young for the job. Knapp did confide in him that he had become a detective, showing him a nickel-plated badge and bragging that he could arrest people.

Joseph Goosman, a Cincinnati furniture mover who had known Knapp for about twelve years and employed him for a time, said that Loony Knapp had once told him that he was organizing a theatrical company and even went so far as to employ young women for the leading roles. Knapp once quarreled with one of Goosman's employees, and Goosman stepped in to keep Loony from getting carved up. People around his stable used to kid with Knapp and lead him on, getting him to tell stories about his great detective work and the showgirls he had hired for his theater troupe. Wilfred Smith, who knew Knapp as a boy, said the young fellow had a habit of digging worms out of the ground to disgust his associates. Knapp also liked to see the reactions of people when he'd place one hand on a board and pretend to chop it off, swinging the hatchet hard and pulling his hand from its path at the last possible instant.

On Friday morning, Knapp's sisters took the stand, beginning with Mattie Rice, who testified about Knapp's various marriages and the many churches he'd joined. He had also told her the previous June that he was going to be mayor of Hamilton.

"I have all the papers fixed," he told her. "It's as easy as anything."

When she saw him the day after Hannah "disappeared" on him, she consoled him and told him not to worry.

Sadie Wenzel followed and "was a good witness for her brother," the *Sun* reported. "She is a bright woman and was better able to describe his eccentricities than any other member of the family. She also told of his accidents and the peculiar manner in which he was awakened. Her description of the way in which the prisoner would hold his head and complain of pain was very good and evidently made an impression. When Mrs. Wenzel was telling of the sufferings of the prisoner from the pains in his head, Knapp acted as if he were in great pain. When his sister told of his holding his head, he bowed and pressed his muscular hands to his temples. He seemed to be suffering and called the attention of Sheriff Bisdorf to his pains."

Sadie said that the color of his eyes changed when he had these spells, and sometimes he would disappear from home for days, returning with wild, impossible stories.

She said he would occasionally try to assault members of the family. He went after her once and tore up a shirt she was ironing for him. He once went after her husband with a knife and another time attempted to assault his father with a hatchet. She said he once took her and Mamie out for a boat ride and almost took them over a dam and would have if their father had not rescued them with another skiff.

William Wallingford, who knew Knapp from 1885 to 1890 when the strangler was in his twenties, said that he was much younger than Knapp but used to play with him on East Fifth Street in Cincinnati. Sometimes, when Knapp got bored with the small boys, he would try to put sand in their mouths. When Wallingford's brother was seven years old, Knapp got him drunk on beer, laid him down in a shed and cut his hair. On occasions, Knapp would have a fit and foam at the mouth.

During the opera season of 1890, Knapp got a job at the Robinson Opera House as a supernumerary, or "super," a non-singing extra to fill out crowd scenes, where Wallingford was a ticket-taker in the gallery. During the production of *Nobody's Claim*, Knapp played the part of an owl. When there were dogs in the show, Knapp would play with them like a child. When he got too excited about something, he would grit his teeth, froth at the mouth and the muscles of his neck would swell. He acted so strange and looked so wild that some of the employees would lock him in an empty room on the stage until he calmed down.

Other people from Knapp's life—"a small army," the *Cincinnati Enquirer* estimated—testified about the bizarre behaviors through the years: walking

A Puzzle to His Attorneys

barefoot in the snow, buying pitchers of beer only to pour the beer in the gutter and break the pitcher in the street, chasing and/or throwing rocks at girls, tying tin cans full of flaming material to the backs of streetcars and putting on a helmet and doublets, his costume from *The Fall of Babylon*, one of the operas he performed in as a super, and acting like he was the real thing.

During her testimony, Sadie said that after his summer with the opera, he got the notion that he was a great actor. When the popular singer and actress Mary Anderson performed at the Grand Opera House, Alfred landed some super work but told Sadie that he had been appointed Anderson's leading man. He said he had to dress her for her performances and got an old valise that he carried around for that purpose. He began to cook, sew and iron around the house and claimed to be a ladies' tailor.

When court was adjourned Friday, Knapp asked a reporter near him, "Is this thing going to last another week?"

"It looks very much like it," he said.

"Well if it does, I do not know what is going to become of me. I can't stand it much longer. The heat is awful," Knapp said. The reporter checked a thermometer in the courtroom. It was ninety-two degrees.

Knapp was much relieved when the reporter told him Sadie and Mamie had finally kissed and made up after Sadie's testimony.

The courtroom also contained something of a celebrity, at least in criminology circles: the Scotsman Dr. J. Sanderson Christison, author of the acclaimed books *Crime and Criminals* and *Brain in Relation to Mind*. He was the official examiner of Leon Czolgosz, the assassin of President William McKinley, and testified as an expert in the trial of Adolph Luetgert, the Chicago sausage maker who killed his wife, boiled her in lye in one of his factory's vats and burned the remains in the factory furnace.

Because he wasn't a witness for either side, Christison was not allowed to interview or examine Knapp. But based on his interviews with the family and others associated with the case, he submitted a report to the media discussing both the issue of criminal insanity and the Knapp case in particular. The esteemed doctor noted that Susannah Knapp had suffered from some mental disturbances as a girl and experienced considerably more disturbance at menopause, saying, "These observations suggest that the prisoner was not entirely free from a tinge of nervous instability prior to his first head injury."

The injury from the colt was to an area of the brain "especially connected with emotion, will and intellect," the doctor said. "As I observed him in the courtroom his looks betokened a mixture of confusion and imbecility

which would preclude a proper realization of his present predicament." He concluded, "Had he not met with injury to his brain in childhood he would in all probability have grown up to be as useful and successful as his two brothers and four sisters, and he would not be where he is now. He cannot be considered a responsible individual."

Sane or Insane?

After two days of hearing the wild tales of all of the people who had ridden on the Alfred Knapp crazy train, the defense began the second week of the trial Monday morning, with Dr. Brooks F. Beebe, a Cincinnati physician and expert on insanity. Because he was an expert witness, he could only testify in the abstract and not specifically on Knapp's case. All that meant was that he and the lawyers had to couch their terms carefully. Beebe took the stand at 11:15 a.m., but he didn't get to answer the first question until almost 2:00 p.m. That's how long it took Darby to ask it.

Darby posed to the doctor a hypothetical question, reciting every strange or abnormal act by the defendant Alfred Knapp since the colt kicked him in the head. He summarized everything already testified to in court, from simple bizarre things like decorating his room with a bouquet of buckets to evil, unconscionable acts like five heinous murders and assorted assaults against women. For over a solid hour, Darby read off the list of peculiarities and atrocities that had been brought out in testimony, finally asking the doctor, "From all these circumstances and the conduct of the individual named, do you consider that he was sane or insane?"

"He is certainly insane," Dr. Beebe replied.

It might have ended right there, but Beebe's testimony continued throughout the afternoon and into the next morning as he gave an even lengthier explanation as to how he arrived at that conclusion. He mulled over every item in the litany of crazy that Darby had packed into his question, weaving into the narrative an elaborate explanation of brain structure and function. But those in the crowded courtroom, especially the defendant, silently and attentively soaked up every word with great interest, even in the intense temperatures in the courtroom and even as the prosecutor's cross examination covered nearly every item of the original hour-long question a third time.

Darby had not been feeling well for the past few days, and the heat was nearly unbearable. In the middle of Beebe's testimony, around 10:30 a.m.

on Tuesday, July 7, Darby suddenly left the courtroom and went into the hallway, where he nearly collapsed and was placed in a chair. Court officials, including Prosecutor Warren Gard, rushed to his aid. Gard led him to Judge Belden's office and helped him to a sofa. Someone procured some cracked ice to put on his brow until Dr. Dan Millikin arrived. Court adjourned until 1:30 p.m., but Millikin ordered Darby to the boardinghouse where he'd been staying during the trial for at least a day, fearing congestion of the brain.

When court resumed, co-counsel Thomas asked for an adjournment for the day, but Gard said he had a witness he wanted to call, so court resumed at 2:30 p.m. when Thomas recalled Edward King to find out more about an incident when Knapp had threatened him with a knife. King also said he'd seen Knapp be unspeakably cruel to animals, once hitting a mule in the eye with a whip without any cause. Knapp was always slovenly and most of the time without a job. As far as King knew, Knapp never held a job longer than a month.

Thomas called one more witness, then asked for an adjournment until Darby could get back to work.

Prosecutor Gard wanted to call H.H. Barnard, deputy warden of the Michigan City penitentiary, who was anxious to get back home that afternoon. His testimony was that he had many conversations with Alfred Knapp and never once thought him insane. He said Knapp never complained of headaches nor ever missed a day of work.

When court resumed Thursday morning, Darby had not yet shown up. Everyone waited patiently for a few minutes, and then Thomas said he wished to enter an almanac into evidence.

He presented a small book to Prosecutor Gard, but Gard said he did not care to see it. Thomas told the court that he wanted the jury to see that the moon had changed on the night of December 21, 1902, from that of a full moon to the last quarter. Gard objected, but the judge overruled, and the almanac with the phases of the moon was entered into evidence.

When Darby arrived, the defense called Mamie King to the stand. She would soon make her husband's prophecy come true. Sadie stood by Mamie's side in the witness stand as she related an incident when the family lived in Rapid City, Illinois—bringing the total number of places the Knapp family lived over the past forty years up to thirty—when she found Alfred lying unconscious in the street. In the middle of her testimony, as she was telling her version of a hatchet attack on their father, it became apparent that she was on the verge of collapse in the sweltering courtroom. Darby, himself still not fully recovered from his brain congestion, asked the judge

for an intermission. Sadie helped escort Mamie from the room, and they barely reached the corridor when she collapsed entirely and was helped to the same sofa that Darby had suffered on just two days previously.

The heat and Mrs. King's collapse had its effect on Darby, who retired to an adjoining room and was given water to place on his head.

Court resumed that afternoon, but Mrs. King did not. Rather, the defense called a few more witnesses and then rested around 3:00 p.m. Gard started his rebuttal by presenting his own small army of witnesses who knew Knapp well and believed him to be sane. This included a recall of Linda Sterritt and a parade of neighbors and co-workers (who were plentiful, as Knapp never held a job for long) who saw him day to day. Also testifying were his barber and his grocer, his jailer and even Lizzie Graham, one of the Graham girls whom John Cable said Knapp wanted to kill. Lizzie said Knapp was always cheerful and lively and as sane as anyone. The craziest thing they knew about Knapp was that he said he used to make big money in a circus and that he was a detective, flashing his badge to prove it. It was slow going because of the oppressive heat in the courtroom. To avoid any further fainting spells, Judge Belden took frequent breaks to allow participants and spectators refreshment.

Gard had hoped to call Dr. Hoppe, who had examined Knapp after his arrest, but he was in Europe and unavailable. Instead, he had Drs. F.M. Barden and C.N. Huston, who called on Knapp at the jail shortly after his arrest. Barden described Knapp as a rugged laborer in good health. He examined the scar on Knapp's head and said there was a wound of the scalp but no depression of the skull. He said he witnessed neither nervousness nor a deviation from natural reaction of the pupils of the eyes. Knapp had a very great tendency toward reading. Barden asked Knapp if he suffered from pains of the head, and he said he did not, nor did he say he had any fits.

"Judging the man from his normal standing, I would say that he is sane," Barden said.

Charley Goddard took the stand again to testify that he had never seen Knapp hold his head or sit apart from others and that he never acted irrationally. Having lived with Knapp, he knew Knapp knew right from wrong.

Finally, the last witness to appear was Thomas Darby, the defense attorney, who was called to rebut the testimony of the Michigan City Deputy Warden Barnard who said that he thought there was nothing insane about Knapp. Darby, however, contended that Barnard told him in the jail that he didn't believe Knapp knew right from wrong.

Knapp seemed nonplussed by the testimony, apparently comforted by the presence of his mother and his sister Sadie at his side.

A Puzzle to His Attorneys

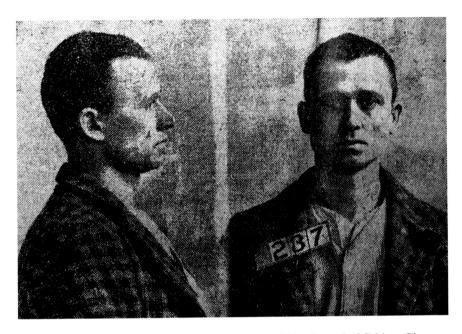

An early mug shot of Alfred Knapp, made during one of his trips to the Michigan City Prison in Indiana. *From the* Indianapolis News.

Both sides finished presenting their witnesses on Saturday, but court would not be re-convened until Tuesday because of a death in a juror's family. Both sides anticipated lengthy closings, so it looked as though it was going to take another week to settle this case.

Summations

The crowds were enormous on Tuesday morning as everyone expected that the real fight would come from the final closing arguments between two well-respected and honored jurists in an emotional battle for a man's life. The doorways were impassable; one woman even sat on an elevation in back of the judge's bench. Some of the courtroom regulars—"the old stagers" who went to every trial—complained about girls in short dresses and barefoot boys in the courtroom. The audience included Darby's father and his personal physician, who kept a close eye on him for any sign of illness. The audience also contained a remarkable number of women and children, especially women—including several of Hamilton's more

prominent maidens and matrons, although they weren't called out by name in the news reports.

Sadie Wenzel brought her brother a bouquet of flowers, which he held throughout the morning session. But even the lovely fragrances and brilliant color couldn't take the sting out of Gard's masterful closing argument, insisting that the prisoner be sent to the electric chair. Knapp seemed to have lost some of his previous confidence about not meeting "Old Sparky," the Ohio State Penitentiary's electric chair. Old Sparky had only been in use since 1887 but had already taken 10 lives (and would take a total of 315 before its retirement in 1963). George Schneider was the last man executed from Butler County, and he was hanged at the county jail. Since Wellner was acquitted on reduced charges and Keelor given life, Knapp would be the first person to be convicted in Butler County to be sent Old Sparky's way. William Haas, the first electrocuted prisoner, was arrested in Hamilton by Captain Lenehan, but his crime was committed in the West Cincinnati suburb of Covedale.

Judge Belden put a time limit for summations at five hours per side.

Gard went first, beginning with a reminder to the jury members of the "solemnity" of their position as they represented "the best and most impartial citizens of the county" because of the care taken in their selection. He also paid tribute to the Hamilton Police Department, Captain Lenehan in particular, for its highly professional efforts and to Mayor Charles C. Bosch for securing the confession. He also lamented that the trial had caused Thomas Darby's illness.

"One moment of Mr. Darby's pain and suffering is not worth the life of a creature such as Knapp," he said. "This is no ordinary case. It is one that has made the whole world stand aghast and the consideration of it should be begin with that fact in mind."

He reviewed in detail the story of Knapp's life, saying that the state had "welded a complete chain" around the prisoner that he could not escape by a defense of insanity.

Knapp listened intently, smiling sardonically a few times at Gard's descriptions of his life and his nutty behavior. Though his speech was masterful and highly entertaining, many eyes remained fixed on the defendant to see how he'd take it, especially when Gard's words turned bitter. Knapp appeared unmoved, even when Gard quoted scripture about the just fate of a murderer.

"Do not be swayed by any sentiment to save this man from the electric chair," he said. "Society demands that he be put out of the way and the state would do it in the most humane way possible."

John M. Thomas opened the summation for the defense, arguing for 90 minutes that Knapp had not been proved guilty because the only evidence against him was the confession, which had not been corroborated on any material point. He also took issue with the manner in which the confession had been secured.

Co-counsel Henry H. Haines spoke next, and apparently inspired by Gard's performance also gave the best speech of his career, "one that surprised even his immediate friends who know his ability," the *Sun* said.

Darby's masterful summation took center stage Wednesday morning, although he was still physically weak from the brain congestion. He began by asking the jurors to be patient with him. He told the jurors that justice should be tempered with mercy and spoke with such eloquence that Knapp's mother and sisters, now all seated with him at the defense table, wept copiously. The *Sun* reported:

> *He went into every detail of the case and endeavored with all the powers of eloquence at his command to convince the jurors that Knapp was not responsible for the crimes he committed—that he was and is insane and that during his periodical* [sic] *attacks of insanity, which date from the time he was kicked by a horse in early childhood, he has not been a free moral agent.*
>
> *Forcefully, splendidly, thoroughly did Mr. Darby plead for his client…for hour after hour without pause for rest.*

The longer he talked, however, the weaker he became. As he neared the end of his address it was manifest to the spectators in the courtroom that the young attorney was struggling to overcome illness and exhaustion and might not be able to conclude. He bravely soldiered on, taking short rests against a table when referring to his notes, and he finished his summation shortly before noon after three hours of intense and eloquent oration.

"I have a picture in mind," he said, "of a woman about, dressed in pure white. It is the former wife of Alfred Knapp, who knew his failings and lack of responsibility. She appeals to you now not to punish him as you would a sane man, but to be merciful with him. At her side I see his dead father who makes the same earnest request knowing as he did of the condition of his son. Above them both is the Savior of the human race whose life was spent in works of love and who begs you to temper your verdict with mercy."

Knapp was overcome by the descriptive oratory, the angelic image of the wife that he loved and strangled. He held his handkerchief to his eyes to cover his face, but his convulsing frame betrayed the silent sobs.

After thanking the jurors for their attention, Darby turned and reeled. His worthy adversary, Prosecutor Gard, quickly offered him a chair.

Belden adjourned the session until 1:30 p.m., and Darby was once again rushed to the judge's office to be attended to by physicians and friends. There was some alarm, but the physician on hand, Dr. Hodges, assured the patient and court officials that this spell was merely the result of overexertion.

A Long Night Ahead

Judge Belden gave the jury its instructions and sent them into seclusion at 5:00 p.m. on Wednesday, July 15, first giving them a nice dinner at Stroble's under the watchful eyes of Sheriff Bisdorf and Deputy Brannon—not to mention the curious crowd lining the route to the restaurant and back, looking for any sign that might give away the verdict even before the first ballot was cast.

Most people seemed to think that it would be a quick verdict, and most figured it would be guilty but with a recommendation for mercy. Not Warren Gard, however. "Knapp is either guilty of first degree murder or he is not guilty at all," he said. "If he is guilty there cannot logically be any recommendation for mercy. I believe that the jury will render a verdict of murder in the first degree without any recommendations attached."

Gard was among a group of men associated with the trial who sat on the steps of the Butler County Courthouse for several hours Wednesday evening, bringing chairs and speculating aloud while they awaited the verdict. A number of other people lingered on the lawn or the stone wall that surrounded the public square, some of them until midnight.

The first hours of deliberation were contentious enough to indicate that it was going to be a long discussion, so court officials prepared a more comfortable room on the third floor of the courthouse for the jurors to rest. At 11:00 p.m., Judge Belden sent word that he was going home and would not receive a verdict until morning. The jury would be locked in for the night, and the men in chairs dispersed, but they didn't go far—just in case.

The jury's first ballot was unanimous on the guilty charge, but they were deeply divided about a recommendation for mercy. Since the jury struggled with an 8–4 vote against mercy, those twelve men, too, settled in for the long night of deliberation. Some of them napped in their chairs between ballots while others carried on the arguments.

A Puzzle to His Attorneys

"There was never any doubt in the minds of any of us that Knapp was guilty and responsible for his crime," said one juror later. "We spent a good deal of time in going over the technicalities raised by the defendant's counsel. Mr. Darby put up a great fight for his client, but the proof was too overwhelming to be put aside. We concluded that Knapp was a monstrous criminal whose career ought to be brought to an end. I suppose people were surprised by our verdict because we stayed out so long, and it was reasonable for the prisoner and his lawyers to hope that we had recommended him to the mercy of the court."

The jury finally reached consensus at 4:15 a.m. They also decided to rest for an hour, every man curling up in a chair, and then have breakfast before court resumed. At 6:30, they called for the sheriff to say they had reached a verdict and ordered breakfast. At 7:00 a.m., Bisdorf went to get Judge Belden, who came straight over to resume court. Thomas was still there from the night before.

It happened so quickly that there were conspicuous absences: Knapp's mother and siblings and the lead counsel for the defense. And in contrast to the thronging crowds that populated the courtroom for two weeks, the twenty-five people present—not a single woman—made the room seem empty.

The jurors were seated before the defendant arrived. The twelve looked tired and worn, exhausted by the night of deliberation.

Knapp was not his usual natty self, either, but rumpled and off-kilter, as if he'd gotten ready in a hurry, which he had. His jailers awakened him from a deep slumber to see what the jury had decided about his future. He was dressed all in black, still wearing the photo pin of Hannah on his lapel. On his way out of the jail he had laughed at a prisoner who had been awakened at the racket. He had bet twenty-five cents worth of cigars to the fellow that he would not get the electric chair. "I'll let you know how it all comes out, boys," he said cheerily as he left the cell.

It was not quite 7:30 a.m. when the agitated Clerk of Courts Hoffman, voice quavering nervously, stumbled through the title and number of the case before he read the verdict: guilty as indicted, no mercy.

The relief was palpable as most of the room generated a big collective audible sigh—"a perfect and painful silence," wrote the *Cincinnati Enquirer*—except for the prisoner, who moved uneasily in his chair and perceptibly trembled, trying to maintain composure but clearly distraught at his fate. He looked to his lawyers—Thomas to Haines—but none met his eye. Thomas was soon on his feet asking for an appeal. Knapp started looking around for his hat even before the judge had finished polling and

giving thanks to the jury when a reporter reached over the rail and tapped him on the shoulder.

"What have you got to say about it, Alfred?"

"Me? Oh, I've got nothing to say. What's the use?" He gave the reporter something of a smile as Sheriff Bisdorf took the prisoner by the arm and led him through the crowd back to the Butler County Jail. It was certain now: Alfred Knapp would never walk again as a free man.

"I Will Not Give Way"

"Poor soul," his mother said when she heard the news. "He doesn't know what's been done."

Sadie Wenzel had not yet awakened when the attorney Thomas went to the house where they'd been boarding to break the bad news, and Susannah Knapp had just risen. Mrs. Knapp tried to remain stoic, but the tears filled her eyes and began to run down her cheeks. She wiped them away with a handkerchief.

"Try to bear up under this," Thomas said. "There is still hope we may be able to do something for Alfred."

"The verdict means he must die, doesn't it?"

Thomas nodded his head.

At that, the dam burst, and all of the poor mother's pent-up grief poured from her eyes as she sobbed, "My poor boy, my poor boy."

She poured out her sorrow to the attorney and his companions from the press, who were by now as familiar to the family as neighbors. Rocking back and forth in the chair, she lamented the shame and grief Alfred's behavior had caused on her other children and how it had killed her poor, dead husband.

"Oh, god, must I lose everything that I have, that I hold dear in this world?" she cried. "Why must I bear such a burden of trouble?"

She collected herself and asked Thomas if Prosecutor Gard was present when the verdict was announced.

"He had no right to walk over in front of me and talk the way he did yesterday," she said. "He had no right to do that. He didn't have to do that to her to make matters worse.

"May God punish him for what he has done!" she said, raising her teary eyes to the heavens. "Oh, I hope he will raise a family that will bring him the trouble that has come to me."

"Mr. Gard was only doing his duty," Thomas said. "He no doubt has the kindliest feeling for you and even for Alfred. It was his duty as an official to prosecute your son."

"No," she insisted. "He didn't have to do what he did."

Just then Sadie came down the stairs, neatly dressed in mourning clothes, her eyes red and heavy from weeping and lack of sleep.

"What is the verdict?" she asked, voice trembling.

"First degree."

"No mercy?"

"No," Thomas said. "No recommendation for mercy."

Tears gathered in her eyes and slowly trickled down her cheeks. She glanced furtively at her mother, still rocking in her chair. Sadie hastily wiped away the tears with the back of her hand.

"I will not give way," she said firmly. "I know that it is necessary for me to keep up my courage. This may not be the end and I will continue to fight for him and to help him if I can. I want to thank you, Mr. Thomas, for what you have done. We appreciate your work and Mr. Darby's most thoroughly and we know that you have done all that you could and that you will do all there may be to do in the future. How is Mr. Darby?"

Darby was, in fact, feeling somewhat better Thursday morning, but his physician—for the past several days his constant companion—said that he was suffering from a severe attack from overwork and nervous exhaustion, and had confined him to bed and prescribed absolute quiet for complete rest and recovery. He barred everyone from the sick room, except his bodyguard—and of course the friendly neighborhood newsman.

"I guess no one cares for the poor fellow but I," the attorney said when a reporter came to the Griner home to give Darby news of the verdict. He sobbed, and his eyes welled with tears. Though it was widely reported that Darby frequently ignored his client and acted as though he didn't like Alfred very much, he did seem concerned about the strangler, nearly offering up his life in sacrifice for his defense, so the tears did not seem forced or obligatory.

NO MATCH FOR OLD SPARKY

Alfred Knapp lost his usual buoyancy when Sheriff Bisdorf and Deputy Brannon led the condemned man out of the courtroom and into the street.

"I didn't think this, but I suppose this ends it," he said. "I don't believe it."

It was still early, but word had already gotten out, and the curiosity seekers began to arrive. The attention seemed to rejuvenate Knapp, and as he approached the jail, he bucked up a little, put a little spring back in his step and looked around as if unconcerned by it all.

When the doors closed behind him in the jail and the bolts clanged, he paused a dramatic moment, gave them a jolly wave and said, "It's all off, boys. I guess I see my finish."

After the jury had been dismissed, Sheriff Bisdorf took them for a tour of the jail. Knapp was sitting at the front of his cell reading the morning paper. He gave one swift glance at the visitors crowding around his cage and buried his face in the pages. He did not look up until they had gone.

At 9:30 a.m., Sadie and his mother called at the jail. Knapp was moved by their grief and wept with them.

"Don't give up, mother," he said. "Remember there is still a chance for me."

When the pathetic meeting ended, Knapp dried his eyes. He would not weep again, at least not in view of a reporter, until his next-to-last day on earth.

That day, eighty women brought flowers to the jail for the strangler. His attorneys told him to "say nothing to no one." He seemed to acquiesce.

Mamie King's reaction was almost an echo of her mother's. "My god, this is horrible," she said through tears when a newspaperman told her the verdict in Cumminsville. "This awful affair killed my father and it will be the death of me…I am a sufferer of heart trouble and I know I will never live to see him executed."

The Strangler's Wife Gets the News

An *Indianapolis News* reporter finally tracked down Anna Gamble Knapp at her new home 693 Bates Alley, arousing the curiosity of the neighborhood when he knocked on nearby doors looking for her. A group of ten women followed him to her door and stood behind him in the street when he asked her if she had any tidings from her husband.

"I have not," she said, "and I'll tell you right now you don't get anything out of me."

"Do you know they have found your husband guilty?"

"No, I don't know anything. What are you trying to do, pump me?"

"I only came here to break the news to you. The authorities are going to execute him."

"What's that?" she said, showing her first sign of interest.

"That means he's going to die by electricity."

"Look here, didn't I tell you I wasn't going to talk to you?"

She pushed past him and out into the street to join the other women.

"You ought to be tickled to death," one of the women said to her. "Just think that Knapp would have got you by the throat sooner or later if the police had not got him."

Another woman hugged her child so tightly that it started to cry. "He might've killed my baby girl if he'd had a chance," she said.

"You bet he wouldn't do me that way," Annie defended her husband. "He treated me right." She started to cry and then dried her eyes defiantly. "I'm going to go see my husband," she said, "if I have to walk."

Goodbye, Hamilton...For Now

Knapp was officially sentenced on September 2. He had quit shaving and looked as destitute and slovenly as he had on the day he was arrested. He wore a white cap until he got into the courtroom. As he took it off, a reporter made a joshing remark about the beard.

"I don't care what I look like," Knapp said without spirit.

Darby presented a few arguments for mercy, but Judge Belden upheld the death penalty. "That's nothin'," Knapp said to Sheriff Bisdorf when they left the courtroom, but back at the jail, he told his fellow inmates, "I got what I deserved."

The sheriff had thirty days to deliver the prisoner to the Ohio State Penitentiary in Columbus, but he had grown desperately tired of the six-month circus and wasted no time. He and a deputy took Knapp on the 10:40 a.m. CH&D train to Dayton where they would catch the Big Four to Columbus.

At first, Knapp seemed pleased, perhaps just for the break in the monotony of the limited travel between the courthouse and jail. He cordially thanked Jailer Clark for the treatment afforded him while he was a guest there. He said he hoped he could come back some time but did not think he'd be able to.

"I'm glad this thing is over, but I was hoping to see my mother and sisters before I left," he said.

When they got him into the alley, the cabs they had ordered had not arrived. "Let's walk," Knapp said. "A little exercise won't hurt me no how."

So they did. Knapp hid his handcuffs under his coat, and they walked the four blocks to the Hamilton Depot. Bisdorf allowed him a drink of beer and let him smoke a cigar while they waited for the train. Knapp got a little nervous when people at the station stared at him, and he began to worry with the irons around his wrists, twisting them back and forth as he talked, but continued to chatter, saying that Governor George Nash would not let him go to the chair.

He told the reporter at the bar that he did not wish to speak for publication because it had always gotten him in trouble, but he didn't shut up. "I feel first class," he said. "I don't remember ever feeling better."

"Aren't you afraid to die in the chair?"

"I haven't the slightest fear," the Strangler said. "I have more nerve than anyone in the country. I believe Governor Nash will commute my sentence and that I will not have to die in the electric chair. If he does not, I shall keep up my nerve until the end. I shall not quiver until the button is pushed and the electricity makes my body shudder. I am going to die game if I have to do, but I have confidence in Nash saving my life.

"If the folks can't get any more money to push this thing, it will be all the same to me. Of course, I don't like the idea of getting electrocuted, but if I have to, why, it's all right."

As they were stepping up onto the train, his knees doubled, and he nearly fell. With that, he lost his good cheer and became morose and didn't speak a word. Bisdorf asked him if he wanted a newspaper, and he said he did not.

Knapp and the receiving clerk at the Ohio State Penitentiary, a Captain Parker, recognized each other from Knapp's earlier stay there. They searched him but did not have him change clothes. They took everything from him except the Bible he carried and then took him to the Annex with the other condemned prisoners: brothers Al and Ben Wade of Toledo, convicted of killing a woman for her money; Lewis Harmon, convicted of killing and robbing an aged man near Columbus; and a young man named Schiller from Belmont County.

Darby was incensed that Knapp had been moved so quickly and without his counsel being informed.

"I knew nothing of Knapp's removal until I saw it in the newspapers," he said and vowed to continue to fight for his client.

A week after his transfer, Knapp spoke to a *Sun* reporter and told him, "I am glad to be here. I didn't like the Hamilton jail. The food was intolerable."

He said he wasn't sure if his family had the money to continue his legal battle and seemed to understand that he was doomed. He was, he said, the most cheerful man in "the Annex of the condemned." The other prisoners were horrified by his utter lack of remorse and the way he joked about his crimes and his likely execution.

Knapp was up to his old tricks again in the interview, telling the reporter that his confession in the Hamilton jail was true, but only half true and that he had some other things he could tell that would surprise the police, but he was waiting for the right time. He said that he ate twice as much as the other condemned men and that he wanted to put on fifty pounds before he sat in the chair.

On September 22, Knapp finally heard from his fourth wife, Annie, but it was not good news.

"I received your letter a while ago," she wrote. "I do not want you to write anymore for I will not answer. Send my picture and the clock. You have disgraced me and Daddie. Good-bye for ever [sic] and ever. From your once would-be wife, for I don't want to be your wife anymore."

Early the next month, however, she recanted, as reported in the *Piqua Daily Call*, primitive spelling and grammar preserved:

> *My Dear husband. I received your letter and was glad to hear from y but I was sorroy the way you taiked to me. But it is all my owne fault, I guest. I ask y to forgiv me for the way I wrote to you, I am ashamed of myself, dear. Pleas forgiv your unhappy wife for all I have wrote to you.*
>
> *Now remember and bare in mind truful friends are hard to find and if you findme that is true, don't chang the old for the new. I haint agoing to get a devoires ellse y want me to. Here is a photo of me, pet. You was so good to me when you was with me. I wish I was with you now but can't be. Chere up for my sak once more. So I will close by asken y to write soon so I will no all.*
>
> *From yr unhappy wife. Annie Knapp.* [See notes section at the end of the book for more information.]

None of the papers printing the letter included any response from Knapp, and with his tenure in the limelight not yet expired, he never again mentioned Annie in any subsequent interviews.

It looked for a time that Knapp might get a new trial. In January 1904, the Circuit Court of Appeals determined that the state had failed to adequately prove that Knapp killed Hannah in the manner alleged in the indictment. Having a body and a confession was not enough proof. Furthermore, the confession of other murders should not have been admitted. "The confession of so many cold-blooded crimes could be the work of only a fiend or a maniac and it could not fail to prejudice any person who heard it read. It, therefore, must have prejudiced the jurors in this case," the judgment read. "It is probably true that the defendant is a criminal of extraordinary magnitude, but it is the province of the court to administer the laws as it finds them and not to make them. Under the circumstances, this court can do nothing but grant a new trial."

Sadie was delighted at the news because she had new evidence in Alfred's own hand that would prove him insane: a score of letters sent to her from prison full of missives of loving expression. At times, she said, the letters showed that he had no recollection of the pending execution and the sentence of the court. At other times, he wrote of his desperate love for her as if unaware that she was his sister.

"Why, the poor fellow would marry me if I would have him," she said.

His fellow prisoners in the Annex, however, were disgusted by the news. How one fellow who confessed to murder should be given such a break was unconscionable to the supposedly innocent men, especially considering how Knapp boasted to them that if he got a life sentence he would be out in a few years.

"If that fellow is got off with life, they ought to quit trying to administer justice," said Mike Schiller, a Youngstown man accused of killing his wife. "They might as well repeal the law against murder."

So he was taken from the Annex and brought back to Hamilton and put in the county jail again until a new trial could be scheduled.

Back From the Annex

The Ohio Penitentiary guard who brought Alfred Knapp back to Hamilton was a Butler County boy named L.B. Sims, who delivered him to the jail at 2:00 p.m. on Friday, January 8, barely five months since he had left. Knapp, who had gained twenty-five pounds in the interim, was handcuffed, and Sims carried a pasteboard box with the prisoner's belongings.

"It's like coming back from the dead," Knapp said. "I told you fellows I would never go to the chair."

He was especially glad to be close to his family again. "I'm going to have my mother and sister up here Sunday," he said. "They say my mother just runs around from one place to another like a crazy woman. This has hurt her worse than it has me."

Sadie and his mother showed up Saturday, a day early and a pleasant surprise for the prisoner. He was overjoyed and kissed them both affectionately and inquired about the health of his brother and Mamie.

Following the visit, his mother's health started to take a drastic turn for the worse, ascribing her illness solely to the grief brought on by her son's crimes. In mid-February, Sadie—now living with her mother at 634 West Ninth Street in Cincinnati—detected the distinctive odor of carbolic acid while passing by Susannah's door. A search revealed a bottle of the antiseptic in her mother's dress pocket. A little bit of it had been used. Fearing that her mother had attempted suicide, she summoned a doctor, who pronounced her well and unharmed but found where a little bit of the acid had spilled on her dress. She was in an "exceedingly nervous state," he said and didn't know what she was doing. Susannah denied buying the bottle to commit suicide but said she wanted to disinfect her bed. Sadie believed she bought it to frighten her.

Even though Warren Gard was no longer the county prosecutor, he continued to work with his successor, Robert Woodruff, in filing motions with the Ohio Supreme Court challenging the appeals court decision. In May, Woodruff and Darby made oral arguments in Columbus.

No Match for Old Sparky

On June 28, the higher court upheld the original jury's decision and set a new execution date: August 19. Knapp was as cavalier as ever.

"Is that so?" he said when he heard the news. "I never thought they would do that. Those judges must be kangarooing, jumping around like that. You tell that old judge and those other loonies that they don't know any more law than I do. Why, it's ridiculous! There is no sense and no right in it."

Once again, he hinted that there were more—or less—of the confessions than he was letting on.

"My sister worked up a case against me, and I got so that I didn't care whether I lived or died. I just began to make confessions, and to say anything they wanted me to. I knew it would get me in trouble, but I didn't care then. I'm sorry now that I made that mistake. But I think I will board here a while yet, anyhow, but I will not go to the chair."

"How do you know you'll never go to the chair?" asked a reporter from the *Indianapolis News*.

"Well, I know I won't."

"Don't you think you ought to?"

"Certainly not."

The reporter said he spoke to Darby, who said he had not yet given up hope.

"That's the boy, that Darby," Knapp said. "That how I know it'll be alright."

"He also said you should not talk so much."

"How do you mean?" he asked, as if he hadn't heard it before.

"Possibly that you should not go crazy and hurt your case."

"I don't see how I can hurt my case by going crazy. I think it might help if I would go crazy."

"Will you die game?"

"You bet I will—but I ain't going to die in the chair."

Now that it was final, the state had one hundred days to carry out the sentence, but Knapp still had hope. Darby prepared an appeal to the state Board of Pardons, which had the authority to commute his sentence to life. Some suggested Darby should take it to the U.S. Supreme Court, but he demurred.

"Unless some new point is disclosed by the decision, there is no constitutional or federal question involved on which Knapp can apply to the United States courts," he said. "There was no federal question raised in the trial of the case. As far as I can see, our only hope is the governor, and an application will certainly be made to him to commute the death sentence."

Luke Brannon, the new Butler County sheriff, accompanied Knapp back to the Ohio Penitentiary on June 12, keeping the departure a secret in light

of rumors of a threat against the prisoner's life. Before he left, Knapp gave several of the jail inmates a photo that the state took of him prior to his original execution date of December 12, 1903, before the appeals kicked in.

"Hello, boys," he greeted his fellow prisoners in the Annex. "This is the third time they've brought me here. They can't keep me and my attorneys will get me pardoned."

Governor Myron Herrick, however, was not to be moved. He sent word to Darby that he would not intervene on Knapp's behalf. His fate rested solely on the Board of Pardon hearing, set for August 9. But it did not look good. Belden sent a letter to the board against commutation, and Warren Gard planned to accompany Woodruff to the hearing to present arguments against the board's interference in the sentence.

Still, as the date neared, Sadie continued to work tirelessly to have his death sentence commuted to life if she could not get him free. Near the end of July, after the Board of Pardons agreed to hear the case, she went to Hamilton to pay a personal visit to Charley Goddard for a long chat. Sadie tried her mightiest to persuade Goddard to sign a petition requesting the board of pardons to change his sentence.

"She talked to me a long time," Goddard said, "but my heart would not allow me to do what she wanted me to do."

Sadie also approached every member of the jury who voted to condemn her brother to sign the petition. They all refused. Likewise, the Board of Pardons voted unanimously to reject the application for pardon. The date was set fast. August 19, 1904, would be Alfred Knapp's last day on earth.

The Strangler Comes Clean

Four days before his execution date, Knapp was charged with attacking one of his fellow inmates, Bill Nichols. Nichols said that he was sound asleep the morning of August 15 when he was awakened by a choking sensation and found Knapp's hands wrapped around his throat. His cries for help—"For god's sake, take Knapp off me! He is trying to choke me!"—woke Annex resident "Dutch" Miller, who leaped from his bed and helped subdue the Hamilton Strangler.

Knapp told the guards he was sick and just got out of bed to go to the lavatory when he bumped against Nichols's bed and swore he never laid a hand on him. His neighbors in the Annex promised to keep an eye on

Knapp for the rest of his days, vowing to add more crimes to their record if he ever tried anything like that again.

The Wednesday before the execution, Sadie came to visit, wanting to get the real story, once and for all, about Alfred's crimes.

"Tell me the truth, Alfred," she said, pleading tearfully on her knees. "Was your confession at Hamilton true? By the love you bore our dear father, I beg of you to tell the truth. I have failed in all I have tried to do for you, and now I want the truth. Allie, tell me!"

Knapp was so moved that he wept with her and tried to pull her up off the floor.

"Get up," he said.

"Here," she said, staying put, imploring, "in the shadow of the gallows, you tell me the truth."

Knapp raised his hand as if taking an oath and looked tenderly at the kneeling woman. "I will tell you the truth, Sadie."

"Was the confession the truth?"

"No," he said.

"Any of it?"

"Yes."

"What?"

"You know what I am here for, Sadie."

"Tell me plainly, Allie," she said. "What is the truth? Tell me, as you hope to meet me in heaven."

"I am guilty of just the last," he said. "Before God, I killed Hannah. I am guilty of the murder of Hannah, but the rest is false."

Sadie, who always believed him innocent, nearly collapsed.

THE FINAL DAY

The night before he was to meet Old Sparky, Alfred Knapp wrote a final letter to his mother:

> *Dearest Mother:*
> *I have not long now to live. In a few hours—30 at most—I hope to be on that bright and golden shore spoken of in the hymns, where no sorrow or trouble ever comes. Now mother, don't weep for me. I but go before, and I know it won't be long before you join me in heaven. I expect to see*

grandpa and grandma, and all the dear ones who have gone before. They'll be waiting for me at the pearly gate. Well, it's all over at last. I'm sorry for all the trouble I've caused you, but don't weep for me, Mother, for I die in Jesus. Now comes my time to say the saddest word that can be said, farewell. Don't weep for me, mother I am going to dwell with Him. I don't think I'll be punished in heaven for what I've done after being in prison so long and having so much trouble.
Your affectionate son, ALFRED A. KNAPP

The letter was written in a shaky, nervous hand, much of it printed as would a child just learning to hold a pencil. "Farewell" was written in large block letters surrounded by a bracket drawn in pencil. "Don't weep for me, Mother" was also enclosed in a little box and repeated several times throughout the letter, like the refrain of a song.

His sister Mamie King had grieved herself ill over the fact that Knapp believed her to be responsible for giving police the information that led to his arrest. The Kings had moved to Covington, across the river from Cincinnati, and had been under the near constant care of a physician for the two weeks leading up to Alfred's execution.

At home on the night of his execution, she was overcome with emotion as the time approached. "My god, my poor brother," she cried out a few minutes before midnight and fell into a faint.

About nine o'clock the next morning, Knapp sent word to the warden that he was hungry. Warden Edward Hershey sent him peaches, bananas and tomatoes, and Knapp ate nearly all of them with relish. In the afternoon, his mother and Sadie called on him as he was writing his lengthy letters of farewell.

"I shall never forget my last talk with my poor boy," Susannah Knapp would tell a reporter after the execution. "It was awful—a dreadful memory for [a] mother to carry through life—but I had to see him before he died. When I entered the death cell Allie was sitting at a table writing. He rose and took my hands. He was as white as my handkerchief and trembling like a leaf."

"Cheer up, Allie," she told him.

"Alright, mother," he said. "Don't worry about me. I've been writing to my sister and you," he said, pointing to the writing table. "I have mailed your letter, mother, but I don't think I can finish the rest. I haven't the strength."

She saw envelopes addressed to Cyrus, Mattie and Sadie, but he didn't finish the letter to Mamie. His final letter was to his attorney Thomas Darby,

No Match for Old Sparky

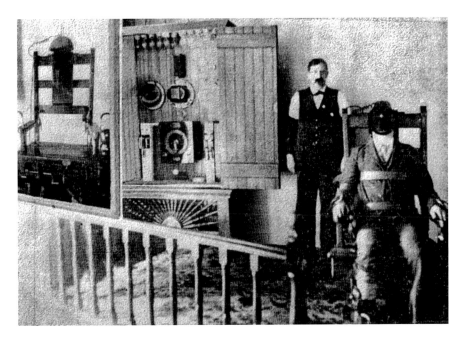

A model poses for photographs of "Old Sparky," the Ohio Penitentiary's electric chair, from the 1908 book *The Palace of Death, or, The Ohio Penitentiary Annex* by H.M. Fogle. *Courtesy of the Smith Library of Regional History.*

which read in part, "Word or pen fail to express my gratitude and admiration for your noble struggle in my behalf, of what was a hopeless case from the beginning." His closing was, "Your unfortunate client, ALFRED A. KNAPP."

Sadie was disappointed that Warden Hershey had denied her admission to the execution.

"I have stayed with him through all his troubles and I can go through this ordeal, too," she argued.

The warden told her that up until that time she had displayed unusually good judgment and that her work on behalf of her condemned brother had been admirable, but that for her to now ask to see him suffer the extreme penalty of the law was useless and a display of poor taste. Sadie was insistent, but Warden Hershey was firm. She did not witness the execution.

Knapp was in fairly good spirits through the day. Toward evening, he seemed to realize his end had come, but he did not weaken. Instead, he played a lengthy, ironic rendition of "There'll Be a Hot Time" on his accordion.

At 6:00 p.m., Knapp ate a hearty supper sent to him by the warden's wife: spring chicken, salad, watermelon, blackberries, sweet potatoes and a glass of milk. He relished the last best of all.

Knapp also disposed of his personal effects by giving his famous accordion to Sadie and his Bible and some books to his mother, who also received a locket to give to a niece. He gave his opal pin to his brother and his ring to Sadie to be given to another relative.

The final disposition of Knapp's affairs and remains were a matter of contention among members of his family for several days. Some of them wanted him quietly buried in a Columbus cemetery, while others wanted his body taken to Cincinnati. He finally settled these affairs by writing a letter turning his affairs over to his sister, Sadie Wenzel, and directing that his remains be buried in Cincinnati.

A few minutes before his execution Knapp changed his mind and decided that his remains would be buried in the Catholic cemetery in Columbus.

One Last Confession

After eating his last meal, Knapp conversed with his fellow prisoners until shortly after 7:00 p.m. when he sent for captain of the penitentiary guard, J.B. Sims, the Butler County native who took him to Hamilton during his brief reprieve from the Annex.

During their journey, Sims had asked him if he could make some statement about the assault on the Motzer children. He told Sims that Joe Roth was not guilty of the assault and that he would make a written statement to that effect.

As the specter of the electric chair grew near, Knapp wanted to give his statement, as he did the others, to Hamilton mayor Charles Bosch, one of four men Knapp had invited to the execution. During his return trip to Hamilton, he sent word several times asking for the mayor to come and see him, but Bosch never did. Knapp asked about him several times that final day, enough that Warden Hershey sent word to Bosch to try to arrive by 9:00 p.m. But time was growing short and Bosch had not arrived, so Knapp gave Sims a statement written in a nervous uncertain hand, with the promise that Sims would deliver it personally to Bosch. Sims promised that if he could not hand it to the mayor that night, he would take it to Hamilton himself.

Ohio Penitentiary Annex,
August 18, 1904.

To whom it may concern: Joe Roth is innocent of the attack on the two Motzer children on September 10, 1902, as I done that myself

but there was no intention of committing rape on them. Now I am doing this to clear Joe Roth's name as I assaulted the children myself. Alfred Knapp.

After this, Knapp spent some time conversing with his fellow prisoners, until about 9:45 p.m. when two priests came to the prison to spend the closing hours of his life with him. During his final days, Knapp had converted to Catholicism, and the priests prayed and gave words of consolation to the condemned man. Around 11:15 that evening, Warden Hershey sent a half pint of whiskey to the priests in the Annex with Knapp, with the request they use their own judgment as to its use. Shortly before midnight, they administered the last sacrament.

While Knapp was being prepared for his execution a few minutes before midnight, he said to one of the guards: "Where are all these newspaper men who said I was going to break down? I don't look like I was going to break down, do I?"

"Well, not very much," the guard said.

At 11:58 p.m., those permitted to see the execution, headed by Warden Hershey, marched from the state prison office to the Annex. The spectators were arranged on a platform in a circle opposite the chair. The platform would not accommodate all the spectators, several of whom stood to one side. These included Mayor Bosch and Sheriff Brannon.

At 12:01 a.m., Knapp was ushered into the death chamber by assistant deputy warden Long, followed by the priests.

"Knapp looked well," the *Democrat* reported. "His skin was white but his face was full and his body plump. If there was any evidence of collapse it was not apparent when he appeared in the death chamber, for he went to the chair unassisted and with that quick, nervous step which is always a characteristic of the man."

Knapp sat immediately in Old Sparky, and guards rapidly adjusted the straps about the legs, arms and neck. While they were engaged, Knapp looked about the death chamber and spied Mayor Bosch to his right, nodded his head and smiled slightly. By this time, the electrode was placed on Knapp's head, and then Warden Hershey said, "Mr. Knapp, have you anything to say before the sentence of the law shall have been executed?"

"Nothing," replied Knapp.

"Goodbye," said Hershey.

"Goodbye," replied Knapp. Then a guard quickly covered Knapp's face with a black mask.

At 12:03 a.m., Warden Hershey turned on the electric current. It would be Hershey's last execution. He took ill in a barber's chair a week later and died of a stomach hemorrhage within four hours.

Three physicians—including a Dr. Goodwin from Indianapolis, who was Knapp's invited guest, having cared for him during his last stay in the Michigan City prison—made a careful examination and, at 12:09 a.m., declared Knapp dead.

"The electrocution was one of the most successful in the history of electrocutions," the papers reported.

The instant the current was turned on, Knapp's body strained against the straps that held it. This lasted but for the few seconds that the full current of 1,750 volts passed through his body. As the current was reduced to 500 volts there was an apparent collapse of the body. Then as the full current was again turned on, Knapp's body became extremely rigid. As the electricity passed through, his skin became red and the muscles of his hands twitched slightly. His body went limp when the switch was finally turned off.

Sadie reluctantly remained in Columbus to attend to the burial and accompanied Susannah to the train station early the following morning. The poor mother was prostrated from the awful strain under which she had labored for months and, on reaching home, sank to a chair and sobbed bitterly.

More than three thousand people filed through the Columbus funeral parlor that held visitation services for Alfred Andrew Knapp, but only Sadie and one unnamed companion escorted the body to the Mt. Calvary Cemetery in Columbus.

Susannah, Sadie and Mattie all went to visit Mamie after Alfred's burial, trying to console her with loving messages. Mamie was beside herself, remorseful for her role in his coming to justice and firm in her belief that she would soon follow her wayward brother to the great beyond.

When Mayor Bosch returned to Hamilton, he shared the confession of the Motzer assault with the newspapers, expressing his belief that it was true and only confirmed the suspicions the people of Hamilton ever since Knapp's first break into the limelight as one of the "greatest criminals of the current era."

The mayor's assessment seemed to rely as much on the horrible handwritten confession of five murders that the Strangler made in his office as the confession in hand. Knapp was no mastermind. His crimes were impulsive and sloppily executed, so it seems unlikely that he could have committed four murders without giving himself away somehow. In the end, his actual criminal record, substantial though it was, paled in comparison to his imagined one. Knapp

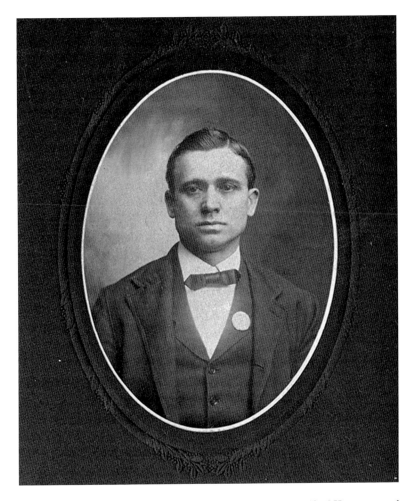

During his brief reprieve while his trial was being appealed, Alfred Knapp passed out copies of his "death portrait" to his fellow prisoners in the Butler County Jail. *Ohio Department of Corrections.*

had a compulsion toward violence that occasionally became irrepressible and the mind of a damaged child. His known victims and his wives were all petite—built like a girl if not literally one—and he never outgrew his childhood fascination for the spotlight, hence his forays into the circus and opera, which in retelling always became more glamorous than the actuality. So when he discovered himself in the public eye for strangling Hannah in her sleep, he finally found a stage with an eager and attentive audience and gladly gave the encore of a spectacular confession—not one more murder but *four*—whether or not it was true.

Alfred Andrew Knapp died in the electric chair almost exactly one year after he bragged to the *Cincinnati Post* that "Old Sparky" wouldn't be able to get the best of him.

"They can't electrocute me because I know how to prevent it," he said. "When they get me to Columbus and put me in the chair and turn on the current, I'll laugh at 'em. It will have no effect on me after I make a little twist I know how to make. I'll just hold myself a certain way and then the electric current will pass off me like water off a duck's back…If they hung people in the state like they used to, it would be different."

Whatever contortion he had planned, it didn't work.

NOTES

The Strangler's Wife

Knapp seemed to feel no contradiction between his professed habit of murder and his religious beliefs. Every town he went to, he would join a church and the religious societies. He had a pleasing singing voice and would join the choirs. On the Sunday preceding his arrest, he joined the Christian Endeavor Society of the Indianapolis Fourth Christian Church on North West Street, which he began attending in mid-January. The congregation welcomed him as a devout man, and he soon requested membership. Soon enough, however, he approached the pastor saying that he was going to a new city and asked for a letter of reference, which the pastor gave him. He said that his new city had no Christian Endeavor Society and that he planned to form one as soon as he got settled.

Goodbye Hamilton...For Now

This was the last report from Anna May Gamble Knapp, the fourth wife, soon to be the widow. On May 11, 1906, the *Indianapolis News* reported that she had to give up the "Strangler's Child" to the Board of Children's Guardians for foster care, the board being of the opinion that Mrs. Knapp was not a fit person to care for the child. The math on that doesn't add up,

however, as a fourteen-month-old child, as the paper reported, would have been conceived in the spring or summer of 1904. By that time, Alfred Knapp would have been prohibited from procreating by the walls of the Ohio State Penitentiary, a pretty reliable prophylactic. An offspring of Alfred Knapp would have to be at least two and a half years old in May 1906. In August 1906, Anna May Knapp married Taylor D. Crump of Indianapolis. Taylor D. Crump died at age thirty-two in June 1909, leaving Annie widowed for the second time. Somehow, thinking of her as the Widow Crump seems apropos. She quickly remarried on November 1, 1910, to Kentucky native Oliver Mains in Jeffersonville. She was thirty, he twenty-two.

BIBLIOGRAPHY

Atlanta Constitution. "Sister Hated by Murderer." March 5, 1903.
Butler County (Ohio) Democrat. "An Indictment Was Returned in the Hatfield Case." January 22, 1903.
———. "Knapp Appreciated Darby's work." August 25, 1904.
———. "Knapp Jovial at the Penitentiary." July 7, 1904.
———. "Knapp's Farewell." August 25, 1904.
———. "Murderers Disgusted by Report." January 21, 1903.
———. Tea Table Talk column. July 28, 1904.
Cincinnati Enquirer. "Alfred Knapp Charged with Having Gone Through an East Fifth Street House." April 9, 1888.
———. "Attorney for Knapp Doesn't Want Him to Testify in the Roth-Motzer Case." March 12, 1903.
———. "Cans Tied to Streetcars." July 3, 1903.
———. "Delayed by Attorney's Illness." July 8, 1903.
———. "Emulated Slayer of Mrs. Geiger." February 16, 1903.
———. "Father of Strangler Knapp Dies at his Home from a Broken Heart." April 28, 1903.
———. "Fiend in the Form of an Athlete." March 1, 1903.
———. "Five Murders on Record of a New Type of Criminal as Personified in Knapp." February 27, 1903.
———. "Foul Murder Committed." February 13, 1903.
———. "Friends and Neighbors of Knapp." July 11, 1903.
———. "Guilty, Verdict of the Jury." July 17, 1903.

———. "Hamilton Man Confesses Murder as a Fine Art but Gives No Motive." February 26, 1903.
———. "Hated Nero and Caligula the Prototypes of Knapp, Whose Joy was Murder." February 28, 1903.
———. "Knapp Calmly Discusses Law." March 28, 1903.
———. "Knapp Must Die in Chair." August 13, 1904.
———. "Knapp Under an Expert's Eye." July 5, 1903.
———. "Knapp Will Be Asked." March 4, 1903.
———. "Mob Silent and Sullen Had Gathered around the Jail at Hamilton." September 19, 1902.
———. "Moon Affects Insane Minds." July 10, 1913.
———. "Mrs. Knapp Says She Did Not Intend to Drink Carbolic Acid." February 18, 1904.
———. "New Trial Granted to Alfred Knap, the Self-Confessed Strangler." January 6, 1904.
———. "Penalty Paid with His Life." August 19, 1904.
———. "Ring Worn by Mrs. Knapp Identifies Body Found in New Albany." March 3, 1902.
———. "Roth Innocent Says Knapp." March 13, 1903.
———. "Sisters of Strangler Knapp Are at Swords' Points." May 5, 1903.
———. "Spirit, Fiendish in Propensities, Which Impelled Knapp to Strangle Women." August 25, 1904.
———. "Stared at the Alleged Stranger." June 24, 1903.
———. "Strangler Knapp's Deadly Weapons Analyzed." March 5, 1903.
———. "Strangler Will Pose for the Crowd." June 23, 1903.
———. "Tears Filled Knapp's Eyes." July 2, 1903.
———. "Tried to Strangle a Cell Mate." August 16, 1904.
Cincinnati Post. "Fear Knapp Shipped Body to Indianapolis." February 28, 1903.
———. "Knapp Is Electrocuted." August 19, 1904.
———. "Knapp Puzzles His Attorneys." March 7, 1903.
———. "'Not Guilty,' Said Strangler Knapp." March 2, 1903.
———. "Officials Thank the Post for Identification." March 3, 1903.
Cone, S.D. "John Yargus who Suicided in County Jail." *Butler County Democrat*, February 11, 1904.
Coshocton Daily Age. "This and That: Crisp Items of Information from Every Crime." July 18, 1903.
Crider, Andrew B., Lester Grinspoon and Brendan A. Maher. "Autonomic and Pyschomotor Correlates of Premorbid Adjustment in Schizophrenia." *Journal of Psychosomatic Medicine* 27, no. 3 (May–June 1965).

Bibliography

Eau Claire (WI) Leader. "Accuses Dead Wife." March 6, 1903.
Fort Wayne (IN) Daily Gazette. "Strangler Knapp Electrocuted." August 25, 1904.
Fort Wayne (IN) News. "Hannah Knapp Buried." March 6, 1903.
———. "Insanity Plea for Strangler." July 1, 1903.
———. "Knapp's Teacher Makes Deposition." July 2, 1903.
Hamilton Daily Republican. "Alfred Knapp Arrested for Death of Wife." February 25, 1903.
———. "Alfred Knapp Confesses Five Murders and Brands Himself the Most Monstrous Criminal Alive." February 26, 1903.
———. "Fear That Hattie Motzer May Die." September 18, 1902.
———. "Foul Assault Committed on Little Girls." September 17, 1902.
———. "Heart Wouldn't Let Him." July 30, 1904.
———. "Knapp Enters 'Not Guilty' Plea." March 2, 1903.
———. "Knapp Has Son Who Is Imbecile." February 28, 1903.
———. "Knapp Now Tells Mayor Bosch That He Has Positively Confessed All His Murders." February 27, 1903.
———. "Motzer Children Getting Better." September 19, 1902.
———. "Samuel Keelor Murders His Wife with a Hammer and Cuts Off Her Head." February 16, 1903.
———. "Stella Motzer Faces Joe Roth." September 22, 1902.
———. "Stella Motzer Names Roth as Her Assailant." September 20, 1902.
———. "Strangler Knapp Talks of Himself." May 12, 1903.
Hamilton Evening Democrat. "Assault to Kill Is the Charge." September 22, 1902.
———. "Confesses to Five Murders." February 26, 1903.
———. "Developments Are Meager." September 20, 1903.
———. "Father of Strangler Alfred Knapp Is Dead." April 28, 1903.
———. "Foul Attempt to Murder Little Girls." September 17, 1902.
———. "Foul Murder Committed." February 25, 1903.
———. "Keelor Entered a Plea of Not Guilty." March 14, 1903.
———. "Keelor Meets His Mother in the Courtroom." May 21, 1903.
———. "Keelor Must Die Says the Jury." May 27, 1903.
———. "Knapp and Keelor Plead Not Guilty." April 4, 1903.
———. "Knapp Executed—Was Good Job." August 25, 1904.
———. "Knapp May Confess to Other Crimes." February 27, 1903.
———. "Knapp Still Talks Despite Advice of His Attorney." March 12, 1903.
———. "Knapp Will Soon Be Given a Hearing." March 10, 1903.
———. "Nothing Revealed in Post Mortem Examination." March 6, 1903.
———. "No Violence Was Attempted." September 18, 1902.
———. "On Trial for His Life Is Samuel Keelor." May 20, 1903.

Bibliography

———. "Palmist Says Knapp Will Live Long Life." March 26, 1903.
———. "Roth's Fate Is With the Jury." March 13, 1903.
———. "Securing a Jury Tedious Work." June 24, 1903.
———. "Testimony of the Bloodhounds." March 12, 1903.
———. "The Bloody Murder of Mrs. Keelor." May 23, 1903.
———. "The Knapp Trial Is Finally Begun." June 23, 1903.
———. "The Post Mortem on the Body of Hannah Knapp to Be Held Today." March 5, 1903.
———. "There May Be a Special Grand Jury." February 28, 1903.
———. "Willing to Pour Oil on the Assailant." September 19, 1902.
Hamilton Evening Sun. "Arguments Open in Murder Case." July 14, 1903.
———. "Awaits His Doom in State Prison." September 3, 1903.
———. "Coolest Man Ever in the Fated Annex." September 11, 1903.
———. "Court Rules that Knapp Must Die in the Chair." June 28, 1904.
———. "Death Halts Knapp Case." July 11, 1903.
———. "Defense Hoping for Verdict of Insanity." July 3, 1903.
———. "Defense Relies on an Almanac." July 9, 1903.
———. "Father of Joe Roth Is Dead." October 4, 1902.
———. "Fourth Wife Visits Fiend." March 4, 1903.
———. "Hannah Goddard Is Laid to Rest." March 5, 1903.
———. "Insanity Is the Defense of Knapp." July 1, 1903.
———. "Is Knapp Lying About Disposition of Box?" February 28, 1903.
———. "King Identifies Body." March 3, 1903.
———. "Knapp Again Made a Plea of Not Guilty." April 4, 1903.
———. "Knapp Arrested for Wife Murder." February 25, 1903.
———. "Knapp Case Nearing End." July 7, 1903.
———. "Knapp Goes to the Electric Chair." July 16, 1903.
———. "Knapp Has Confessed!" February 25, 1903.
———. "Knapp Held for Murder." February 26, 1903.
———. "Knapp Is Held to Grand Jury." March 16, 1903.
———. "Knapp's Attorneys Are Much Incensed." September 4, 1903.
———. "Knapp Seems to Be Weakening." June 25, 1903.
———. "Knapp's Mother Attempts Suicide." February 17, 1904.
———. "Knapp Soon to Know His Fate." July 13, 1903.
———. "Knapp Surprised by Mother and Sister." January 1, 1904.
———. "Knapp to Soon Know His Fate." July 15, 1903.
———. "Knapp to Testify in the Roth Case." March 10, 1903.
———. "Made an Effort to Kill Wife No. 1." February 27, 1903.
———. "Motzer Girl Is In a Critical Condition." September 19, 1902.

———. "None Wants to Serve as Juror." June 23, 1903.
———. "Pleads Not Guilty." March 2, 1903.
———. "The Knapp Case Is Closing." July 10, 1903.
———. "The Motzer Child Somewhat Better—A Medium's View." September 20, 1902.
———. "There Is the Man—Joe Roth." September 22, 1902.
———. "The Talk of Mob Violence Made Hamilton Uneasy." September 18, 1902.
———. "The Work of a Fiend." September 17, 1902.
———. "Says Knapp Is Insane." July 6, 1903.
———. "Strangler Wants Change of Venue." May 9, 1903.
Indianapolis News. "Bessie Draper's Testimony." October 1, 1895.
———. "Body in Box Received Here?" February 28, 1903.
———. "Death for Knapp, Jury So Decides." July 16, 1903.
———. "Death Returns." June 12, 1909.
———. "Governor Will Not Interfere in Execution of Murderer." July 6, 1904.
———. "Indiana Man on Trial." May 19, 1903.
———. "Knapp Gains in Weight." January 9, 1904.
———. "Knapp Gets New Hearing." January 5, 1904.
———. "Knapp Gets 10 Years." October 3, 1885.
———. "Knapp Indicted for Murder of Wife." March 28, 1903.
———. "Knapp Meets His Sister, Mrs. King." June 30, 1903.
———. "Knapp Receives a Letter." September 23, 1903.
———. "Knapp's Mental Condition." July 6, 1913.
———. "Knapp's Sisters Tell of His Queer Actions." July 3, 1903.
———. "Knapp Voted Illegally." March 10, 1903.
———. "Knapp Will Be Executed." June 28, 1904.
———. "Mother of Murderer Admitted to Hamilton Jail." May 5, 1903.
———. "Mrs. Knapp's Body Found in the River." March 3, 1903.
———. "Mrs. Knapp's Child in Indiana School." March 2, 1903.
———. "Protest Filed in Knapp Case." August 5, 1904.
———. "Strangler's Child Taken." May 11, 1906.
———. "Wife Is Missing; Husband Is Held." February 25, 1903.
———. "Witnesses Testify That Knapp Is Crazy." July 2, 1903.
Leiter, Clayton A. "Knapp Assaulted Motzer Children." *Butler County Democrat*, August 25, 1904.
Piqua (OH) Daily Call. "Knapp's Wife Now Begs Forgiveness." October 3, 1903.
San Francisco Call. "Murderer Knapp Grows Contrite." March 2, 1903.
San Francisco Chronicle. "Talks Glibly on Murders." February 28, 1903.

Taylor, W.J. "Knapp Reveals Another Horror." *Cincinnati Post*, March 3, 1903.

———. "Sends Threat of a Suicide." *Cincinnati Post*, March 5, 1903.

INDEX

B

Bisdorf, Butler County sheriff Peter 45, 48, 69, 72, 74, 81, 88, 113, 114, 117, 119
Bosch, Hamilton mayor Charles 23, 37, 38, 42, 45, 48, 70, 79, 128, 129, 130
 testifies 101

C

Cincinnati
 Burnet Woods 14
 Mount Adams 15
 Wade Street Bridge 16
Cincinnati Enquirer 13, 15, 16, 48, 55, 59, 61, 66, 95, 99, 104, 113
Cincinnati Evening Post 49, 74, 82, 132
Cumminsville 13, 22, 25, 31, 33, 76, 77, 118

D

Darby, Thomas 87, 88, 93, 101, 106, 111, 115, 119, 120, 122, 123
 testifies 108
Draper, Bessie 20

G

Gard, Butler County prosecutor Warren 38, 43, 71, 72, 80, 89, 91, 93, 100, 107, 108, 110, 112, 122
Goddard, Charles (Uncle Charley) 11, 23, 24, 29, 36, 60, 64, 78, 92, 124
 testifies 93, 100, 108

H

Hamilton Daily Republican 49, 97
Hamilton Evening Democrat 36, 43, 68, 78, 82, 89, 91, 98, 129
Hamilton Evening Sun 11, 30, 35, 36, 37, 73, 74, 76, 78, 82, 96, 97, 98, 111
Hamilton True Telegraph 43

I

Indianapolis, Indiana 11, 20, 23, 27, 28, 31, 44, 63, 67, 81, 101
Indianapolis News 49, 81, 118, 133

Index

K

King, Edward 12, 15, 22, 25, 28, 29, 61, 78, 107
 testifies 100
King, Mary (Mamie) Knapp 12, 14, 15, 22, 24, 29, 44, 61, 62, 76, 95, 96, 101, 105, 118, 126, 130
 testifies 107
Knapp, Alfred
 announces fourth marriage 29
 appears in court 70, 93, 94, 98, 111, 113
 arrested for bigamy 11
 arrested in Indianapolis 32
 arrives in Hamilton under arrest 36
 assaults Bessie Draper 20
 attacks Amanda Krustaner 87
 attacks inmate 124
 confession 39, 46, 125, 128
 examined by psychiatrists 44, 61
 execution 129
 final letter to mother 125
 gets out of prison 13, 14, 21, 22
 gets photographed 72
 in Butler County Jail 36
 in Cumminsville 25, 76
 interrogation 45
 interviewed by reporters 55, 68, 74, 97
 in the Butler County Jail 117
 kicked in the head by a colt 53, 101, 106, 111
 last meal 127
 learns of father's death 95
 marries Emma Stubbs 14
 marries Hannah 13
 meets Darby 87
 moves to Hamilton 23
 moves to Indianapolis 32
 nickname 102
 palm reading 75
 questioned about Motzer case 37
 recants confessions 97
 receives verdict 113
 rents a wagon 24
 sells Hannah's belongings 27
 shows scar in court 101
 testifies at Roth trial 91
 threatens Graham girls 22
 transported to penitentiary 119
 under interrogation 37
 visited by Littleman 67
 visited by milkman 83
 visited by wife 81
 visits the scene of the crime 42
 works for circus 15
Knapp, Anna May Gamble 28, 31, 44, 49, 65, 77, 81, 118
Knapp, Cyrus, Jr. 67, 95, 96
 testfies 103
Knapp, Cyrus, Sr. 29, 32, 78, 94
Knapp, Emma Stubbs 14, 56
Knapp, Hannah Goddard 22
 allegedly assists in murder of Mary Eckert 57
 allegedly assists in the murder of Mary Eckert 68
 allegedly kills child 48
 body found 77
 confides fear 29
 early life 11
 funeral 85
 marries Alfred Knapp 20
 related to Captain Lenehan 101
 seeks divorce 23
 testifies at inquest 19
 wineroom scandal 53, 62, 66
Knapp, Jennie Connors 13, 14, 15, 16, 56, 58, 102
Knapp, Susannah 29, 32, 66, 78, 95, 105, 114, 122, 126, 130
 testifies 101
Kuemmerling, Hamilton police chief Gus 37, 42, 45, 47, 70, 78, 84
 testifies 93

Index

L

Lawrenceburg, Indiana 14, 52
Lenehan, Hamilton police captain
 Thomas 24, 45
 arrests Knapp 11, 32
 arrests William Haas 110
 begins investigation 30
 escorts Anna May Gamble Knapp 81
 pallbearer for Hannah 79
 related to victim 101
 signs Knapp's confession 47
 testifies 90

M

Marion, Indiana 14
Motzer, Hattie and Stella 37, 38, 89, 128

O

Owings, George 28, 31, 50, 65

R

Rice, Martha A. (Mattie) Knapp 16, 130
 testifies 103
Roth, Joe 35, 37, 128

S

Sterritt, Linda 12, 22, 27
 testifies 100, 108

T

Terre Haute, Indiana 14, 20, 101

W

Wenzel, Sadie Knapp 29, 52, 61, 62,
 66, 70, 83, 95, 102, 107, 108,
 110, 114, 117, 121, 124, 125,
 126, 130
 denied entry to execution 127
 testifies 104

ABOUT THE AUTHOR

After twenty-five years writing the first draft of history as a writer and editor for his hometown newspaper, the *Hamilton Journal-News*, Richard O Jones left the grind of daily journalism in the fall of 2013 for a life of true crime. His first book published by The History Press, *Cincinnati's Savage Seamstress: The Shocking Edythe Klumpp Murder Scandal*, was released in October 2014. Mr. Jones maintains the True Crime Historian blog (www.truecrimehistorian.com) where he

Richard O Jones in the *Hamilton Journal-News* archives at the Butler County Historical Society. *Photo by Sandra M. Orlett.*

remembers the scoundrels, scandals and scourges of America's heartland and publishes the Two-Dollar Terror series of novella-length ebooks. Mr. Jones, a creative writing graduate of Miami University, Ohio, spent most of his career as an arts journalist and has won numerous awards for his reviews and profiles. In 2004, he was named a fellow of the National Endowment for the Arts Theatre and Musical Theatre program at the Annenberg School of Journalism. The Ohio Associated Press named him Feature Writer of the Year in 2011. Since leaving the newspaper world, Mr. Jones has become an active member of his local history community as a board member of the Butler County Historical Society, a member of the History Speakers Bureau and a regular presenter at Miami University in a program titled "Yesterday's News." The Michael J. Colligan History Project of Miami University presented Mr. Jones with a Special Recognition for Contributions to Public History for his coverage of the Centennial Commemoration of the Great Flood of 1913.